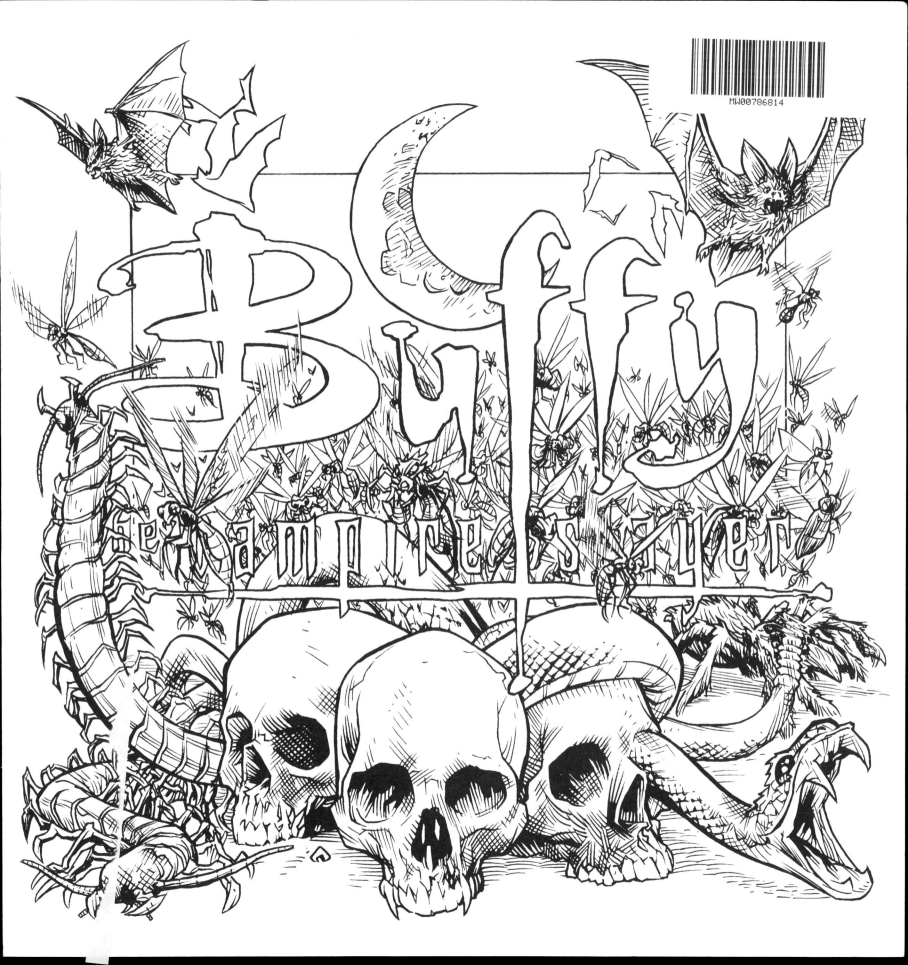

President and Publisher
MIKE RICHARDSON

Editor
FREDDYE MILLER

Assistant Editor
KEVIN BURKHALTER

Designer
SARAH TERRY

Digital Art Technician
CHRISTIANNE GOUDREAU

Special thanks to Nicole Spiegel and Carol Roeder at Twentieth Century Fox.

BUFFY THE VAMPIRE SLAYER: BIG BADS & MONSTERS ADULT COLORING BOOK

Published by Dark Horse Books
A division of Dark Horse Comics, Inc.
10956 SE Main Street, Milwaukie, OR 97222

DarkHorse.com

To find a comics shop in your area, call the Comic Shop Locator Service toll-free at (888) 266-4226.
International Licensing: (503) 905-2377

First edition: September 2017 | ISBN 978-1-50670-458-6

Neil Hankerson Executive Vice President • Tom Weddle Chief Financial Officer • Randy Stradley Vice President of
Publishing • Matt Parkinson Vice President of Marketing • David Scroggy Vice President of Product Development
Dale LaFountain Vice President of Information Technology • Cara Niece Vice President of Production and Scheduling
Nick McWhorter Vice President of Media Licensing • Mark Bernardi Vice President of Digital and Book Trade Sales
Ken Lizzi General Counsel • Dave Marshall Editor in Chief • Davey Estrada Editorial Director • Scott Allie Executive
Senior Editor • Chris Warner Senior Books Editor • Cary Grazzini Director of Specialty Projects • Lia Ribacchi Art
Director • Vanessa Todd Director of Print Purchasing • Matt Dryer Director of Digital Art and Prepress • Sarah
Robertson Director of Product Sales • Michael Gombos Director of International Publishing and Licensing

1 3 5 7 9 10 8 6 4 2
Printed in the United States of America

Buffy
the vampire slayer™
BIG BADS & MONSTERS

ADULT COLORING BOOK

With Illustrations by
STEPHEN BYRNE

PABLO CHURIN

NEWSHA GHASEMI

GEORGES JEANTY

YISHAN LI

KARL MOLINE

TAYLOR ROSE

DARK HORSE BOOKS

Into every generation a Slayer is born:
one girl in all the world, a Chosen One.

She alone will wield the strength and
skill to fight the vampires, demons, and
the forces of darkness.

To stop the spread of their evil and the
swell of their number.

She is the Slayer.

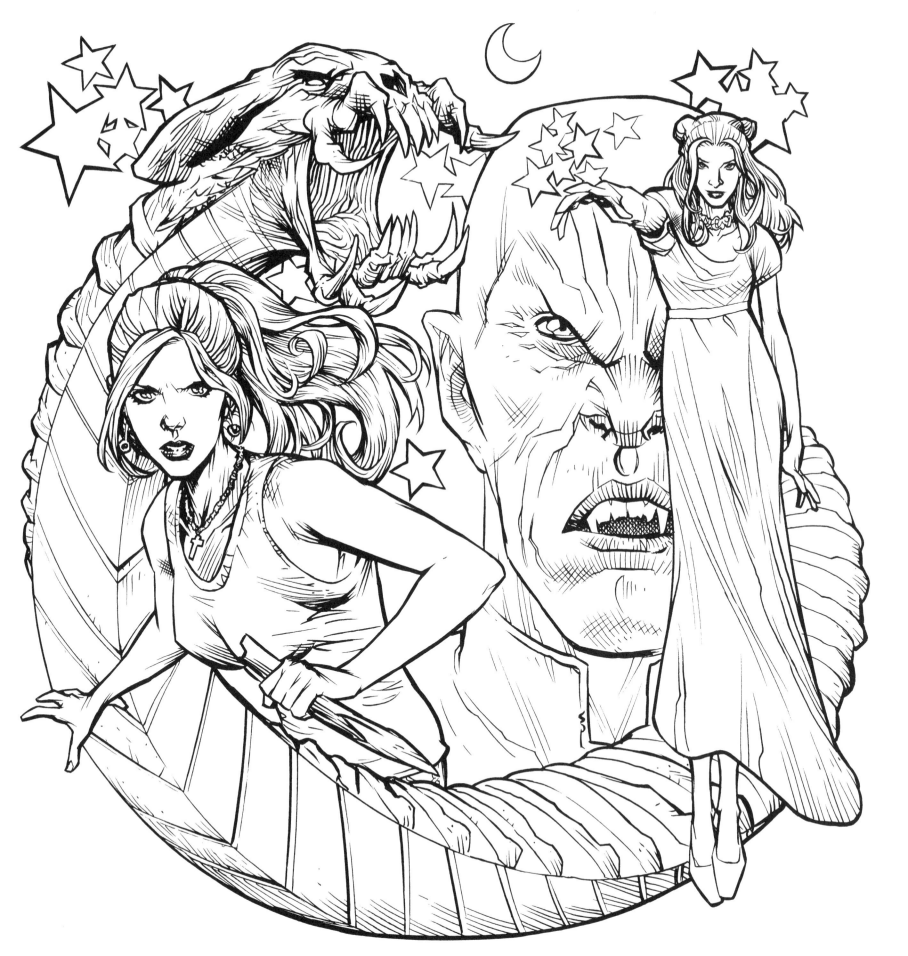

Andrew Wells: Don't torture me and send me to an eternal pain dimension!

Willow Rosenberg: I'm not gonna!

Andrew Wells: Warren killed Tara. I didn't do it, and he was aiming for Buffy anyway.

Willow Rosenberg: Not making it better.

Andrew Wells: And you got your revenge. You killed my best friend. We're even.

Willow Rosenberg: Even? You think I get satisfaction from what I did?

Andrew Wells: Maybe not, but let me keep my skin, okay? I'm not bad, I'm not bad anymore. I'm good, I do good things now.

Willow Rosenberg: Then, why do you need lots and lots of blood?

Andrew Wells: I am bad. I'm bad. I'm evil. But I'm protected by powerful forces. Forces you can't even begin to imagine, little girl. If you harm me you shall know the wrath of he that is darkness and terror. Your blood will boil and you will know true suffering. Stand down, she-witch, your defeat is at hand . . .

Willow Rosenberg: Shut your mouth! I *am* a she-witch. A very powerful she-witch. Or "witch" as is more accurate. I am not to be trifled with . . .

Andrew Wells: But I . . .

Willow Rosenberg: I'm talking, don't interrupt me, insignificant man! I am Willow, I am Death. If you dare defy me, I will call down my fury, exact fresh vengeance, and make your worst fears come true! Okay?

—Season 7, "Never Leave Me"

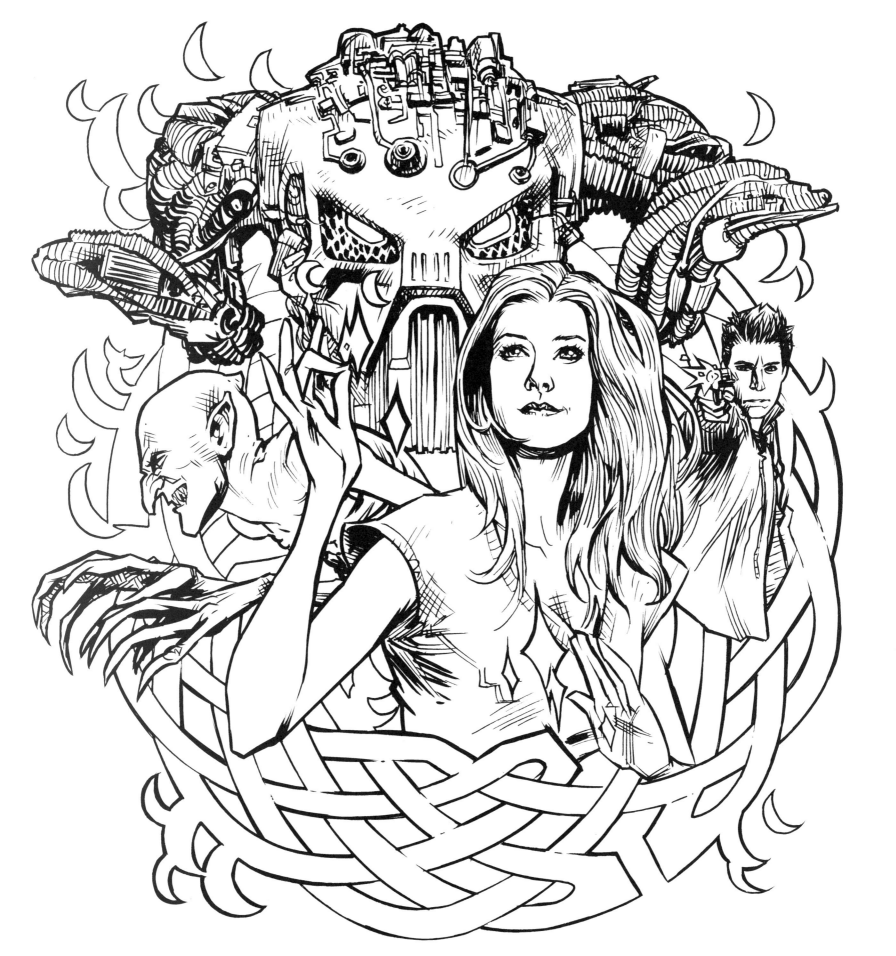

Xander: Seven years, Dawn. Working with the Slayer. Seeing my friends get more and more powerful. A witch. A demon. Hell, I could fit Oz in my shaving kit, but come a full moon, he had a wolf-y mojo not to be messed with. Powerful. All of them. And I'm the guy who fixes the windows.

Dawn: Well, you had that sexy army training for a while, and—and the windows really did need fixing.

Xander: They'll never know how tough it is, Dawnie. To be the one who isn't chosen. To live so near to the spotlight and never step in it. But I know. I see more than anybody realizes because nobody's watching me. I saw you last night. I see you working here today. You're not special. You're extraordinary.

Dawn: Maybe that's your power.

Xander: What?

Dawn: Seeing. Knowing.

Xander: Maybe it is. Maybe I should get a cape.

Dawn: Cape is good.

Xander: Yeah.

<div align="right">—Season 7, "Potential"</div>

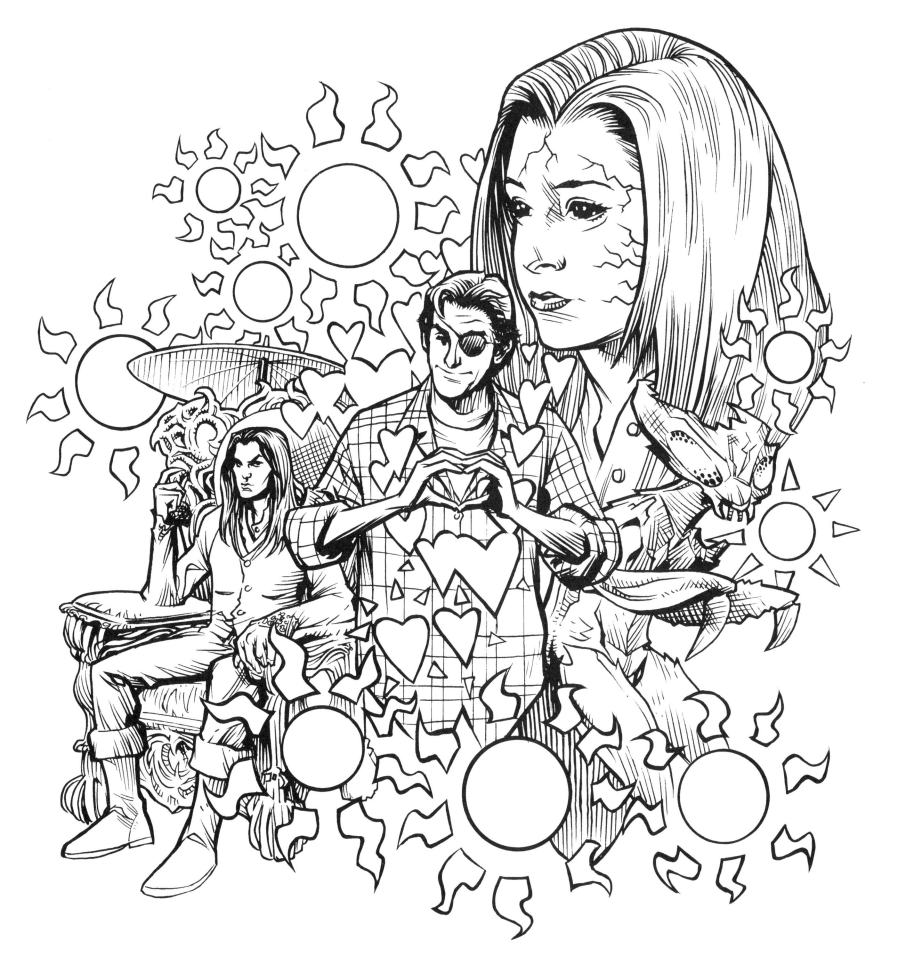

Master: You're dead!

Buffy: I may be dead, but I'm still pretty. Which is more than I can say for you.

Master: You were destined to die! It was written!

Buffy: What can I say? I flunked the written.
 —Season 1, "Prophecy Girl"

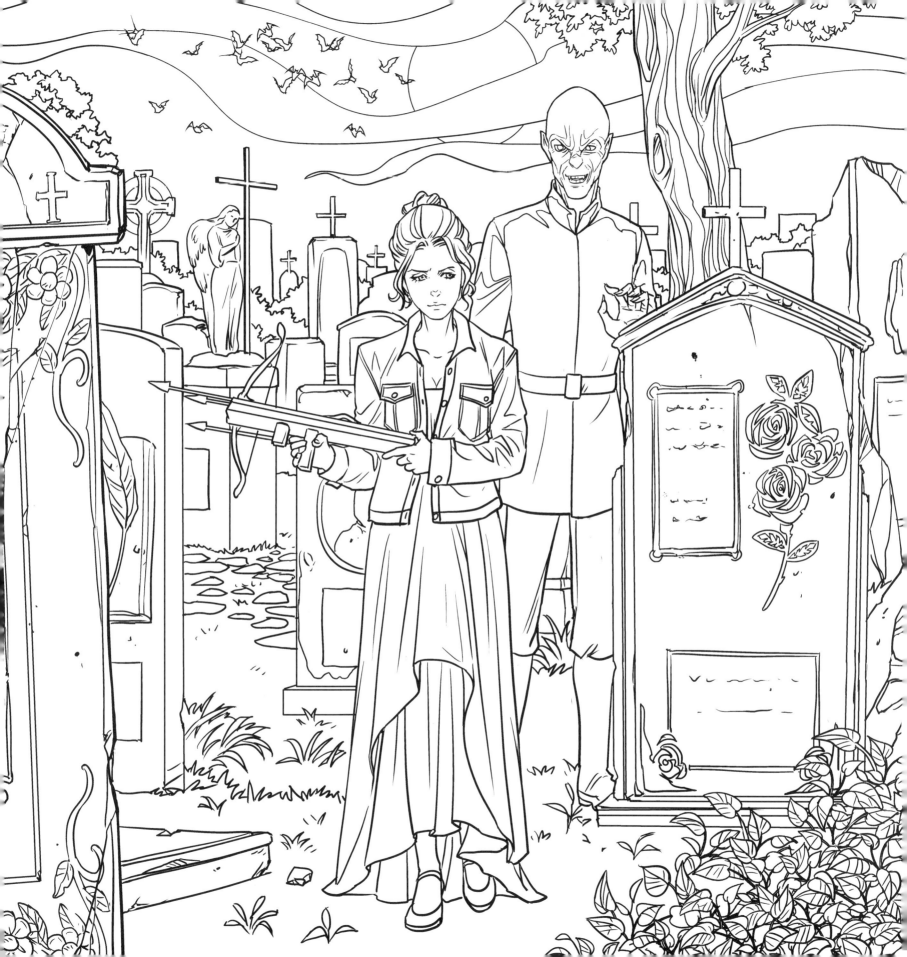

Museum Guide: Five hundred years ago, the Incan people chose a beautiful teenage girl to become their princess.

Willow: I hope this story ends with, "And she lived happily ever after."

Xander: No, I think it ends with, "And she became a scary, discolored, shriveled mummy."

—Season 2, "Inca Mummy Girl"

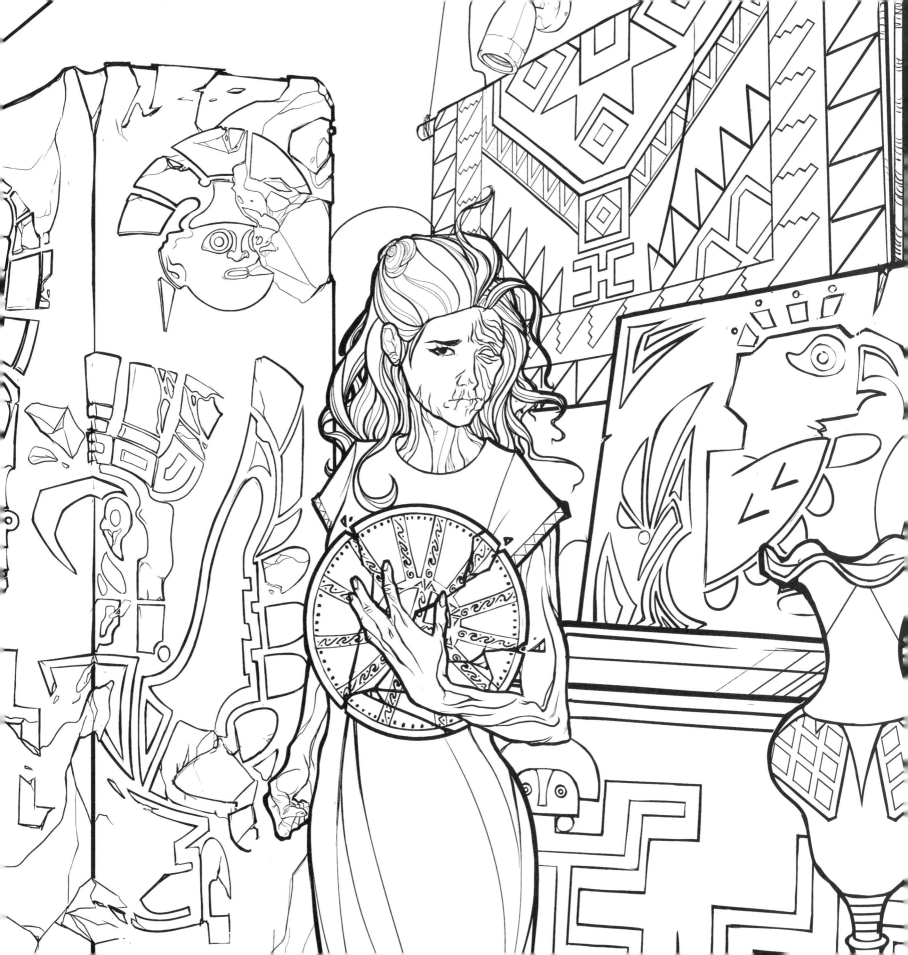

Buffy: I told one lie. I had one drink.

Giles: Yes, and you were very nearly devoured by a giant demon snake. The words "let that be a lesson" are a tad redundant at this juncture.

Buffy: I'm sorry.

Giles: So am I. I . . . I drive you too hard because I-I know what you have to face. From now on no-no more pushing, no more prodding. Just, uh, an inordinate amount of nudging.

—Season 2, "Reptile Boy"

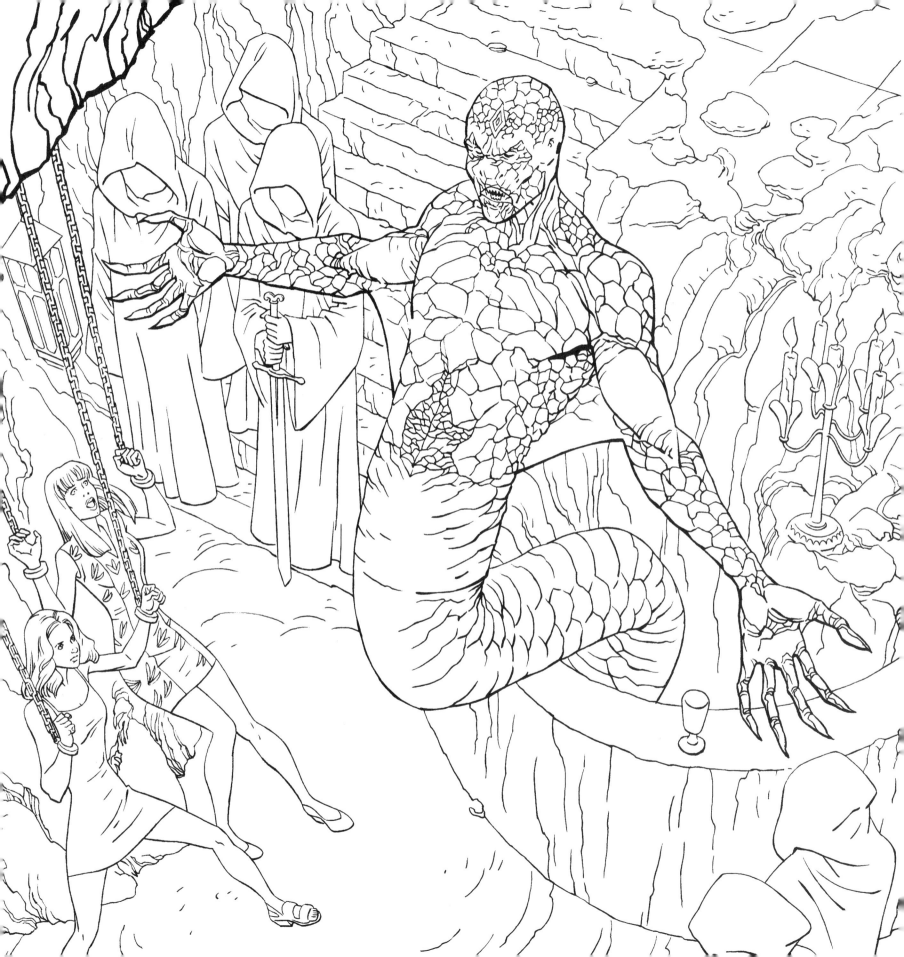

Angel: I need some information.

Willy: Yeah? Man, that's too bad, 'cause . . . I'm stayin' away from that whole scene. I'm livin' right, Angel.

Angel: Sure you are, Willy. And I'm taking up sunbathing.

Willy: C'mon, man. Don't be that way! I-I treat you vamps good! I-I-I-I don't hassle you, you don't hassle me . . . We all enjoy the patronage of this establishment. Everybody's happy, right?

—Season 2, "What's My Line, Part 1"

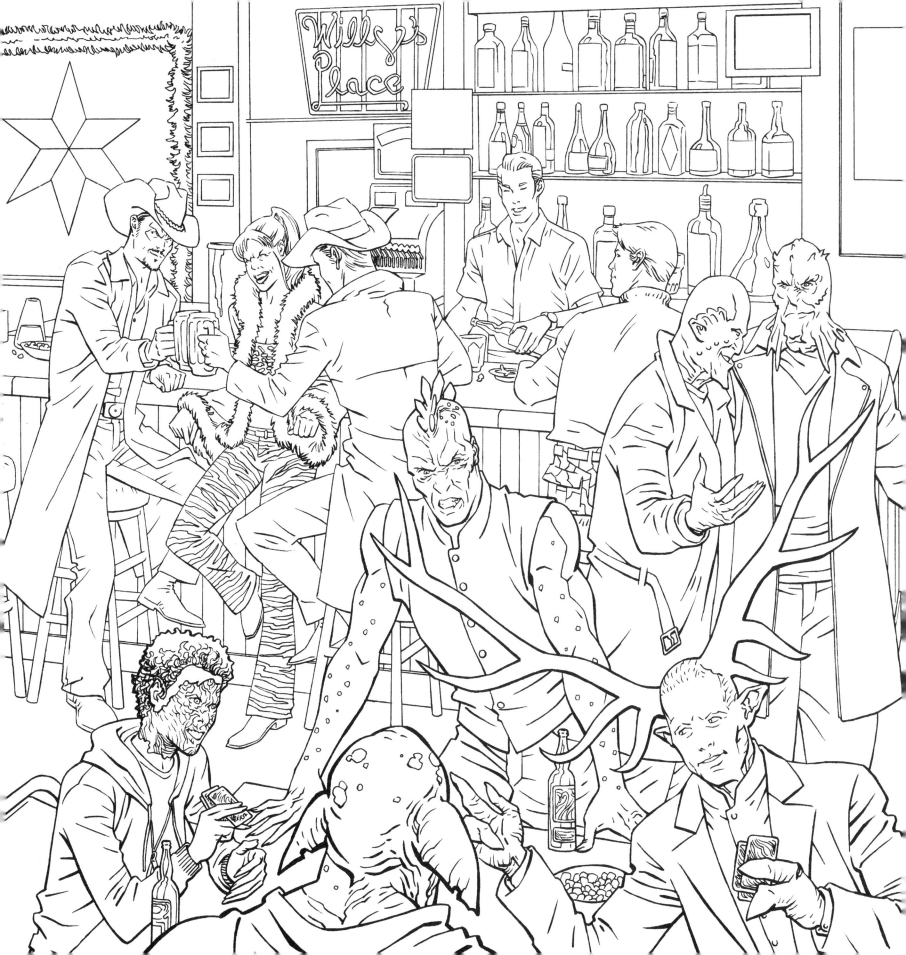

Sid: This is what I do. I hunt demons. Yeah, you wouldn't know it to look at me. Let's just say there was me, there was a really mean demon, there was a curse, and the next thing I know I'm not me anymore. I'm sitting on some guy's knee, with his hand up my shirt.

Willow: And ever since then you've been a living dummy?

Sid: The kid here was right all along. I shoulda picked you to team up with. But I didn't because . . .

Buffy: Because you thought *I* was the demon.

Sid: Who can blame me for thinking? Look at you! You're strong, athletic, limber . . . nubile . . . I'm back! In any case, now that this demon's got the heart and brain, he gets to keep the human form he's in for another seven years.

—Season 1, "The Puppet Show"

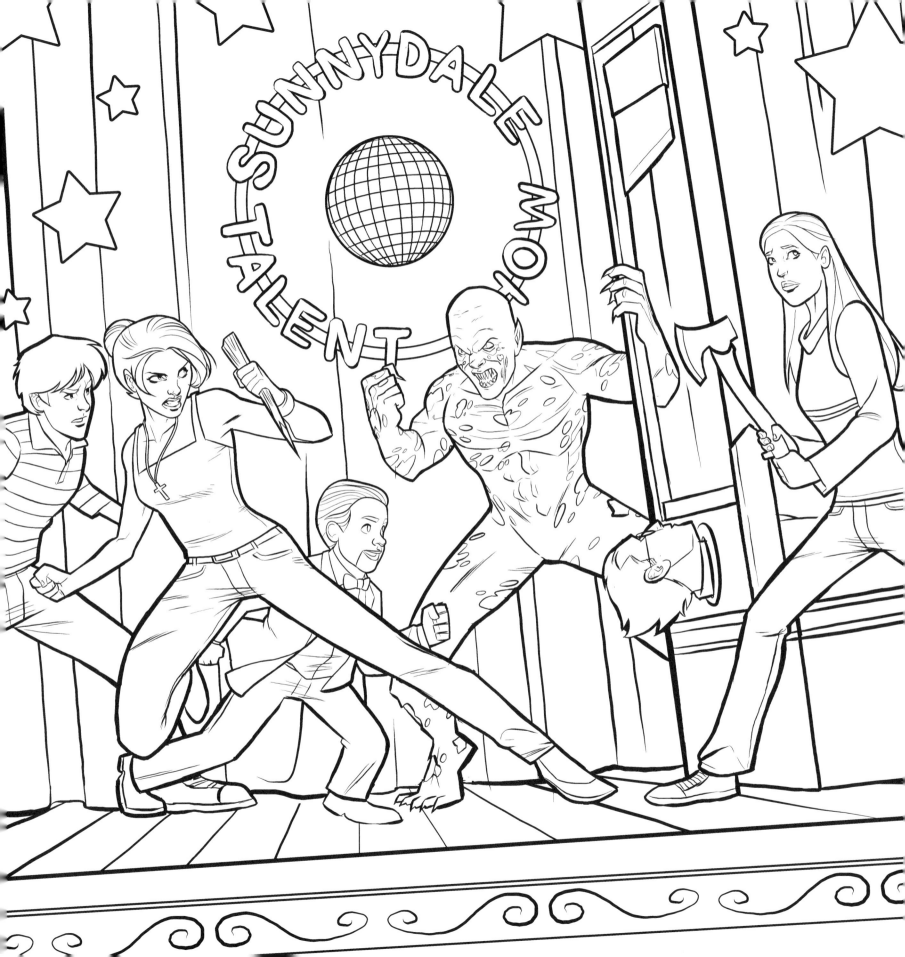

Kendra: So, you believe that Spike is attempting to revive this Drusilla to health?

Giles: Yes, well, I-I-I-I think that's the, uh, the dark power that your, your Watcher re-referred to. You see, uh, you see Drusilla's not only evil, she's, uh, well, she's also quite mad, and-and-and-and if she's restored to her full health, then, uh, well, there's no, absolutely no telling what she might do.

Kendra: Then we will stop Spike.

Buffy: Oooh, good plan! Let's go! Charge!

Giles: Buffy . . .

Buffy: It's a little more complicated than that, John Wayne.

Giles: Yes, I'm, I'm afraid it is. You see Spike has also called out the Order of Taraka to keep Buffy out of the way.
—Season 2, "What's My Line, Part 2"

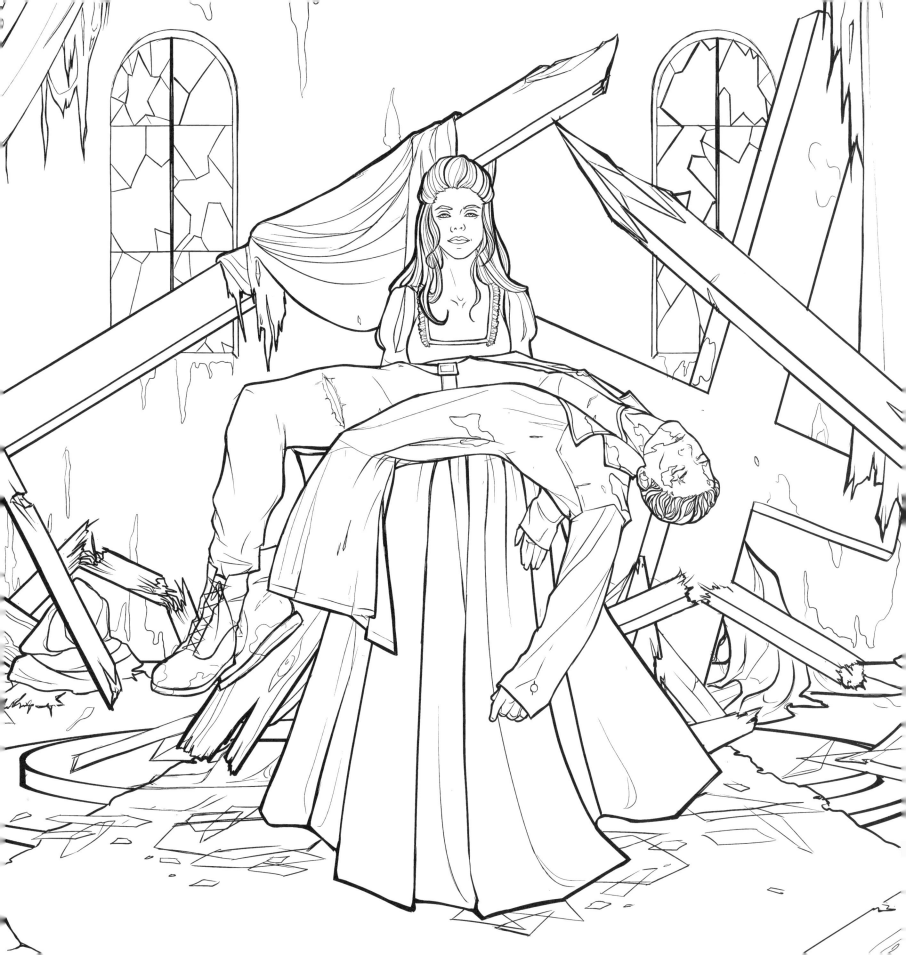

Cordelia: It's called Der Kindestod.

Cordelia: The name means "child death." This book says that he feeds off of children by sucking the life out of them. Eew! But anyway, afterwards, it looks like they died because they were sick.

Buffy: So it did kill Tina.

Cordelia: Yeah, that's my take. 'Cause it would be looking at the children's ward as basically an all-you-can-eat kind of thing, y'know.

Giles: Uh, the, um, the Kindestod gorges by sitting atop his prey, pinning it down, uh, helplessly. Then he slowly draws out the life. I-it must be, uh, h-horrifying for the victim.
 —Season 2, "Killed by Death"

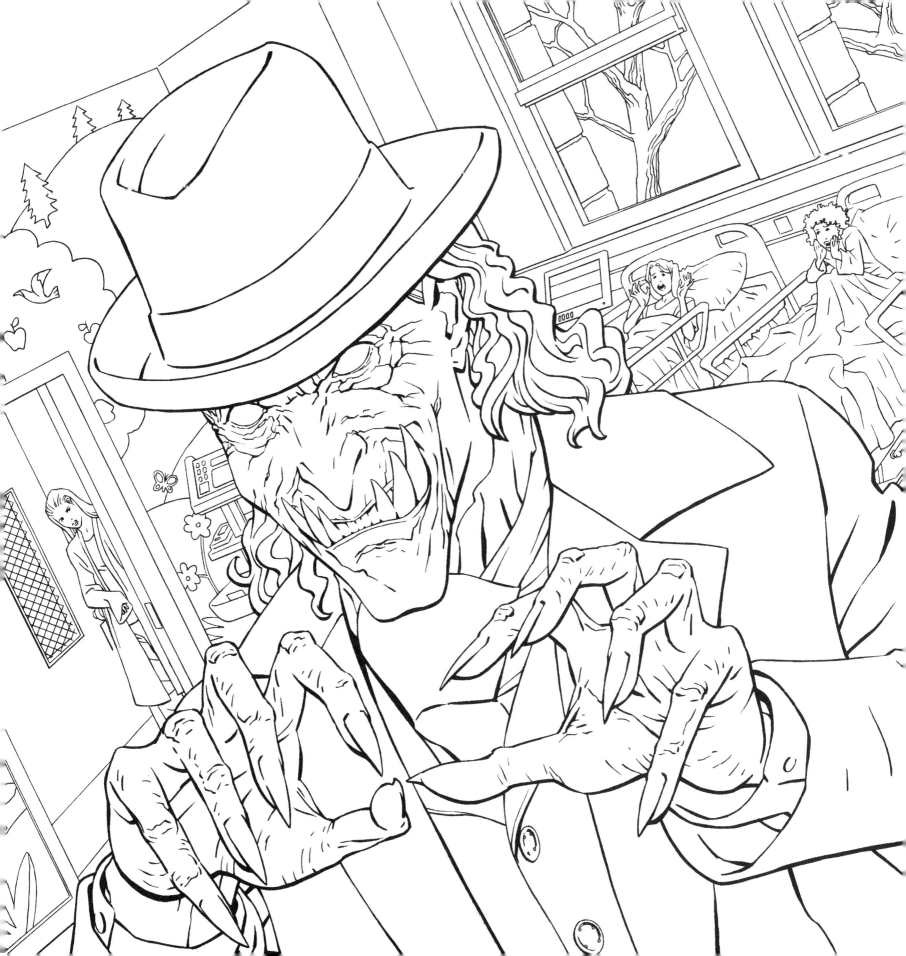

Giles: He's-he's trying to . . . resolve whatever issues are keeping him in limbo. W-what exactly those are, I'm not—

Buffy: He wants forgiveness.

Giles: Yes. I imagine he does. But when James possesses people, they act out exactly what happened that night. So he's experiencing a form of purgatory instead. I mean, he's, he's doomed to . . . to kill his Ms. Newman over and over and over again, and . . . forgiveness is impossible.

Buffy: Good. He doesn't deserve it.

Giles: To forgive is an act of compassion, Buffy. It's, it's not done because people deserve it. It's done because they need it.

Buffy: No. James destroyed the one person he loved the most in a moment of blind passion. And that's not something you forgive. No matter why he did what he did. And no matter if he knows now that it was wrong and selfish and stupid, it is just something he's gonna have to live with.

Xander: He can't live with it, Buff. He's dead.
—Season 2, "I Only Have Eyes For You"

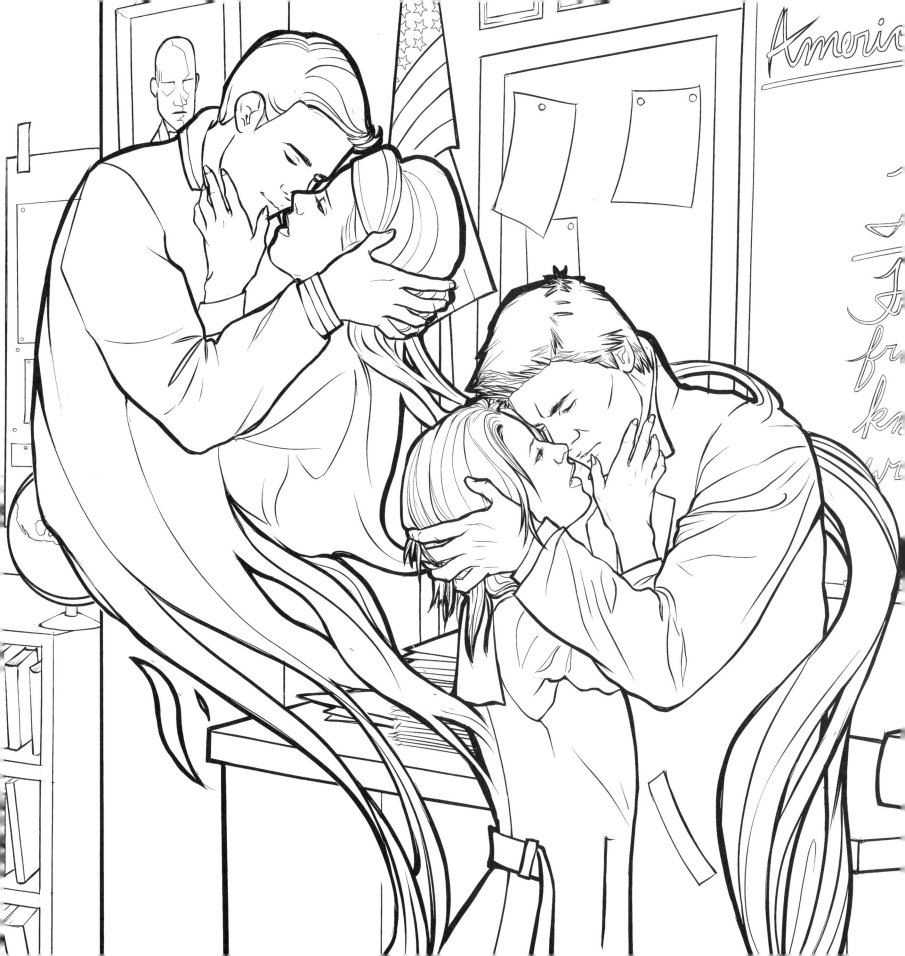

Judge: You're a fool. No weapon forged can stop me.

Buffy: That was then . . . This is now.

Judge: What's that do?

—Season 2, "Innocence"

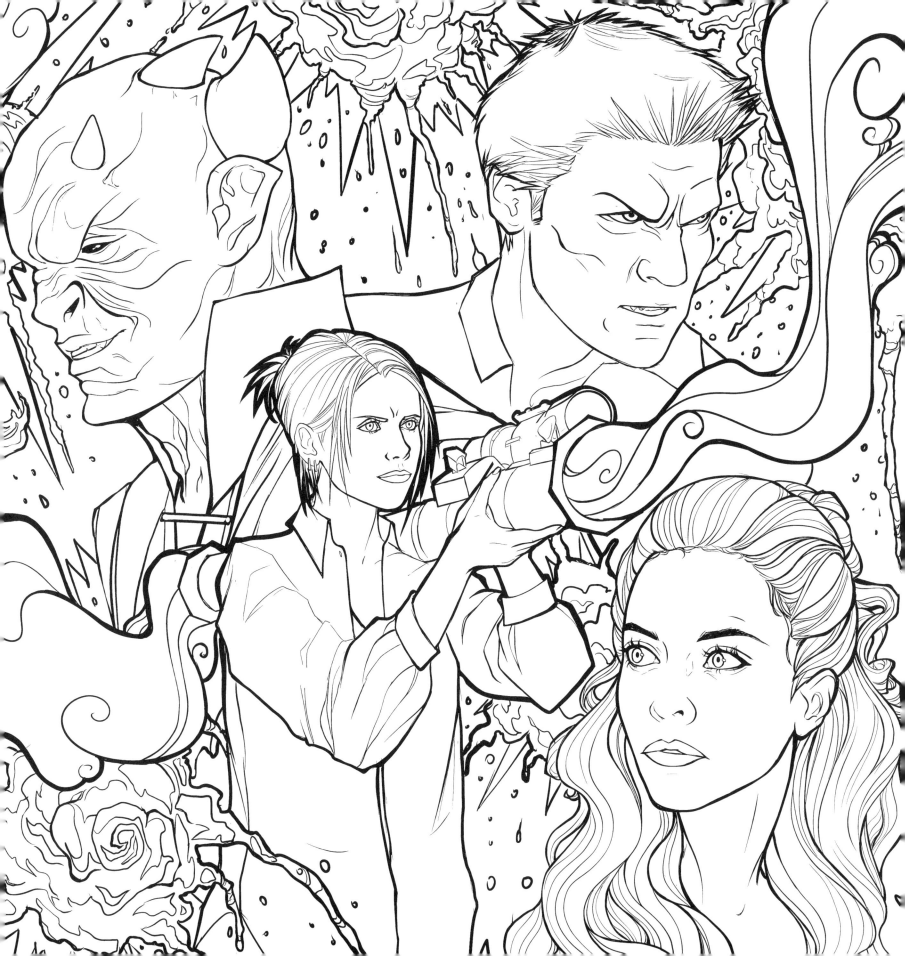

Oz: We should find Giles. He'll know what's going on, right?

Buffy: Sure. 'Cept for all we know he's sweet sixteen again.

Willow: He's with your mom at his place . . . It'll be okay when we get to Giles.

Oz: Of course. I mean, even if he's sixteen he's still Giles, right? He's probably a pretty together guy.

Willow: Yeah, well . . .

Oz: What?

Buffy: Giles at sixteen . . . less "together guy," more "bad-magic, hates-the-world, ticking-time-bomb guy."

Oz: Well then I guess your mom's in a lot of trouble.
 —Season 3, "Band Candy"

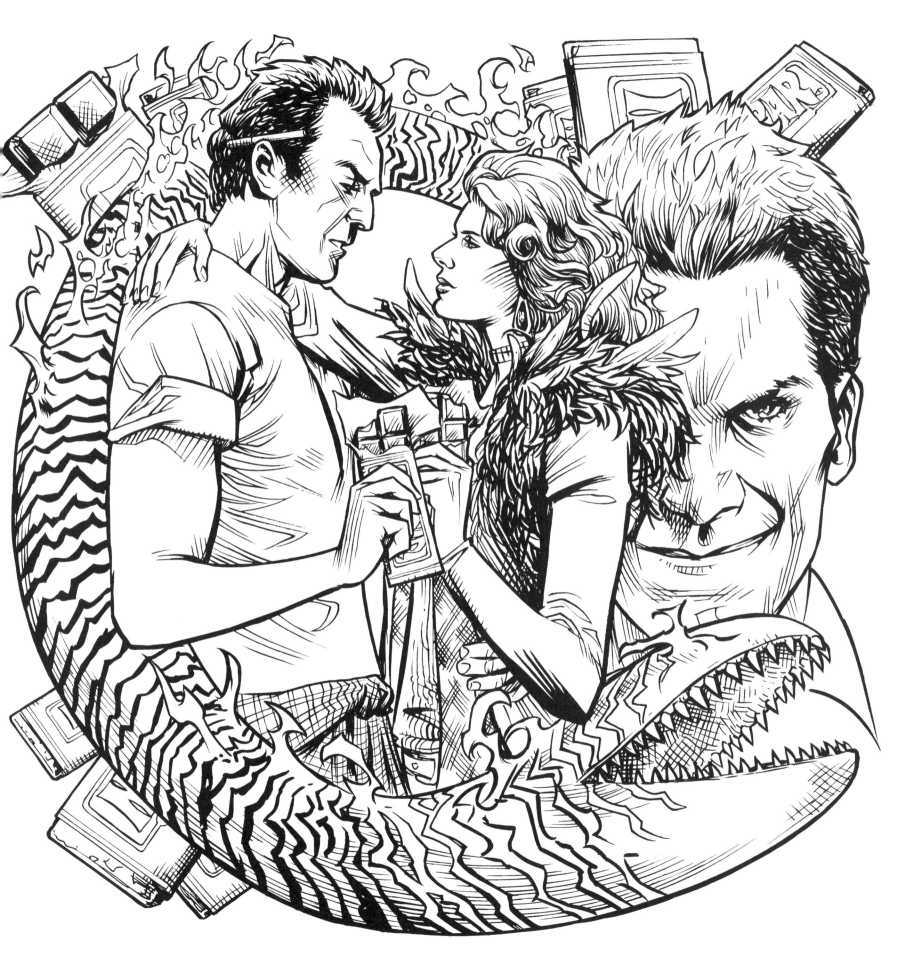

Buffy: Look, Gwendolyn Post—or whoever she may be— had us all fooled. Even Giles.

Faith: Yeah, well, you can't trust people. I should've learned that by now.

Buffy: I realize this is gonna sound funny coming from someone that just spent a lot of time kicking your face . . . But you can trust me.

Faith: Is that right?

Buffy: I know I kept secrets, but I didn't have a choice. I'm on your side.

Faith: *I'm* on my side, and that's enough.

Buffy: Not always.

—Season 3, "Revelations

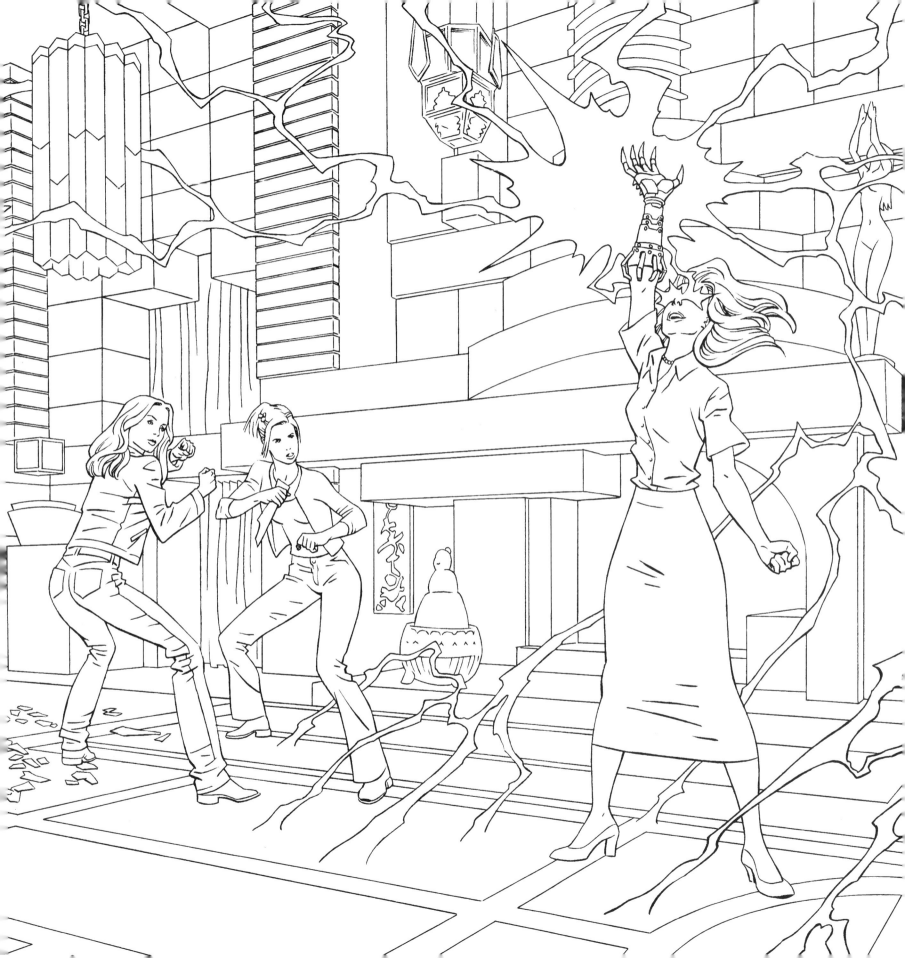

Vampire Willow: Bored now. This is the part that's less fun: when there isn't any screaming.

Cordelia: What's up with you two and the leather?

Vampire Willow: Play now?

Vampire Xander: It's not that I don't appreciate your appetite, Wil, but I thought we agreed it was my turn.

Vampire Willow: Emph.

Cordelia: No. No. *No way!* I wish us into bizarro land and you two are still together? I can *not* win.

Vampire Xander: Probably not. But I'll give you a head start.

Vampire Willow: I love this part.

Vampire Xander: You love all the parts.

— Season 3, "The Wish"

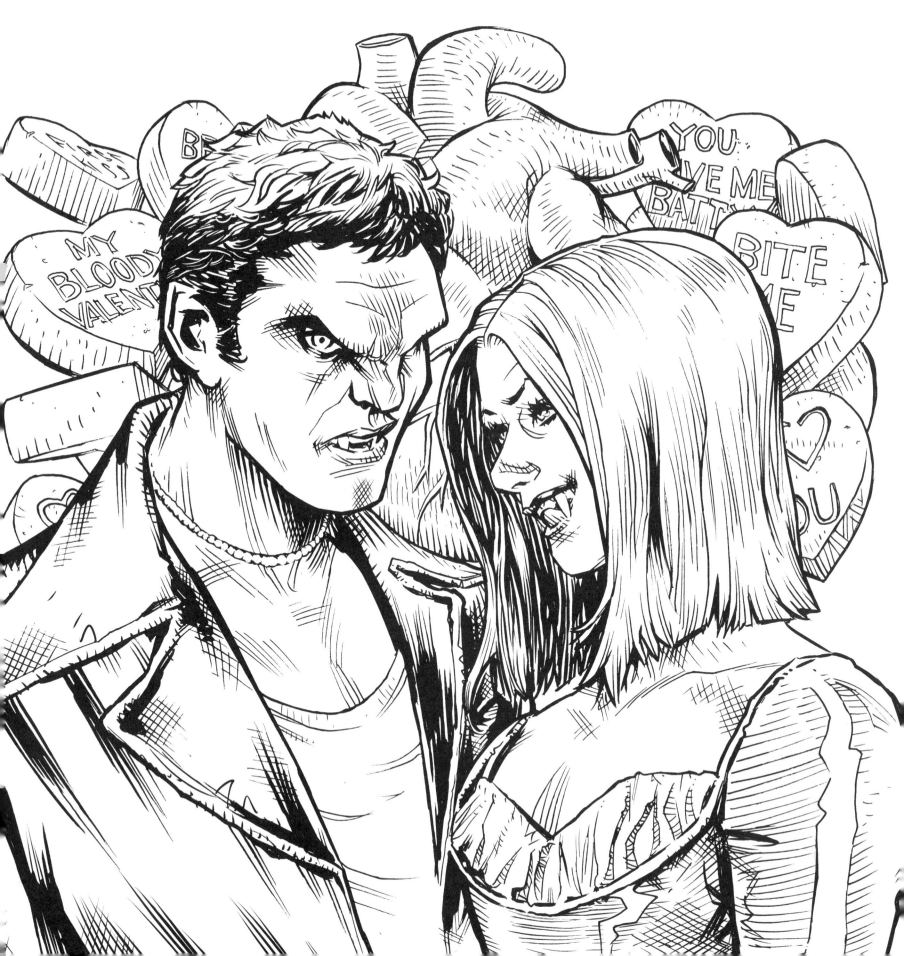

Giles: There is a fringe theory, held by a few folklorists, that some regional stories have actual, um, very literal antecedents.

Buffy: And in some language that's English?

Oz: Fairytales are real?

Buffy: Hans and Gre . . . Hansel and Gretel?

Xander: Wait. Hansel and Gretel? Breadcrumbs, ovens, gingerbread house?

Giles: Of course! Well, it makes sense now.

Buffy: Yeah, it's all falling into place. Of course that place is nowhere near this place.

Giles: Some demons thrive by fostering hatred and, and, uh, persecution amongst the mortal animals. Not by, not by destroying men, but by watching men destroy each other. Now, they feed us our darkest fear and turn peaceful communities into vigilantes.

Buffy: Hansel and Gretel run home to tell everyone about the mean old witch.

Giles: And then she and probably dozens of others are persecuted by a righteous mob. It's happened all throughout history. It happened in Salem, not surprisingly.

Xander: Whoa, whoa, whoa. I'm still spinning on this whole fairytales are real thing.

Oz: So what do we do?

Xander: I don't know about you, but I'm gonna go trade my cow in for some beans . . . No one else is seeing the funny here.

—Season 3, "Gingerbread"

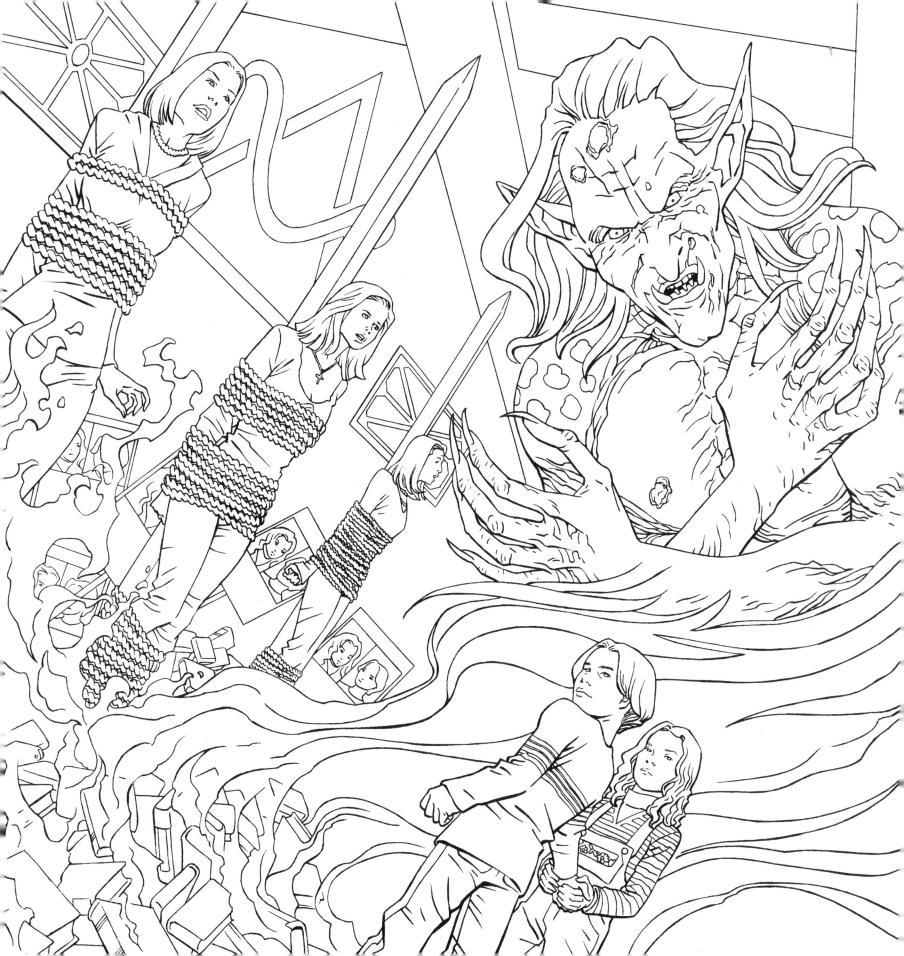

Zachary Kralik: Y-You don't seem to understand your place in all of this. Do you have any idea—Oh my! What have you . . . My pills? No. No . . .

Buffy: If I was at full Slayer power, I'd be punning right about now.

Zachary Kralik: No! No!

—Season 3, "Helpless"

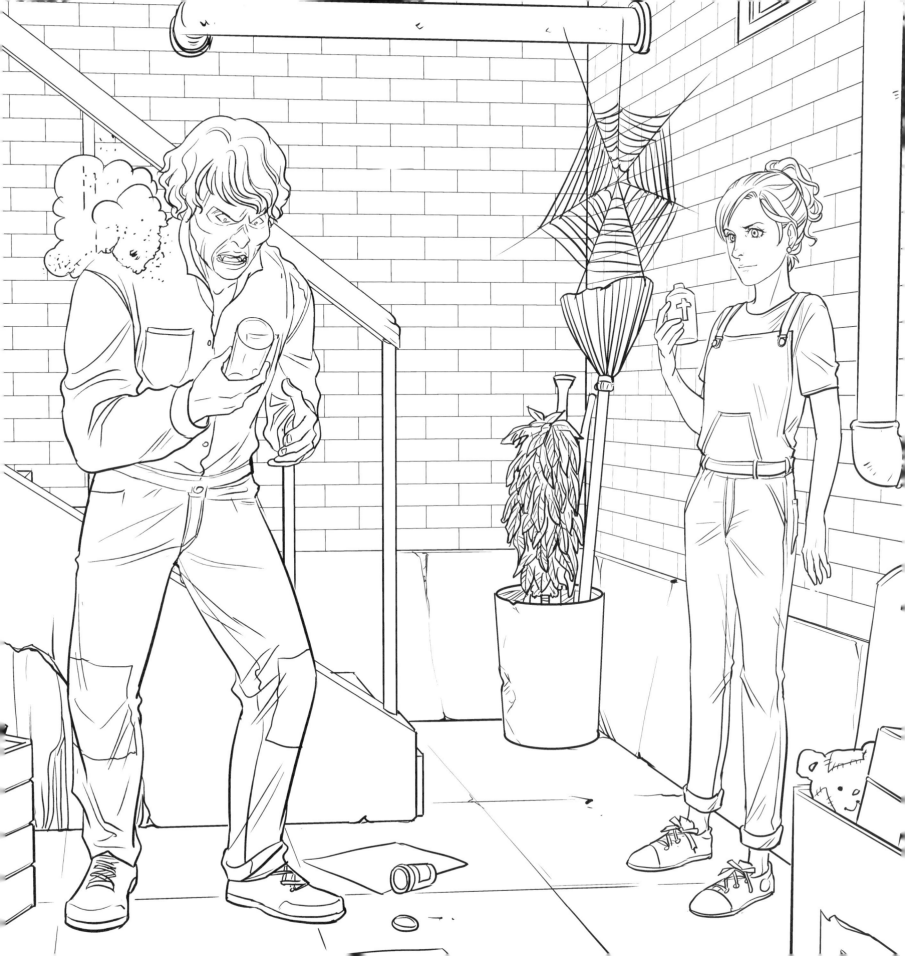

Giles: They seem fairly committed. The Sisterhood of Jhe is an apocalypse cult. They exist solely to bring about the world's destruction, and we've not seen the last of them. More will follow.

Buffy: And they're here in Sunnydale for what? Demon Expo?

Giles: Buffy, this is no laughing matter.

Buffy: Hence my no laughing.

—Season 3, "The Zeppo"

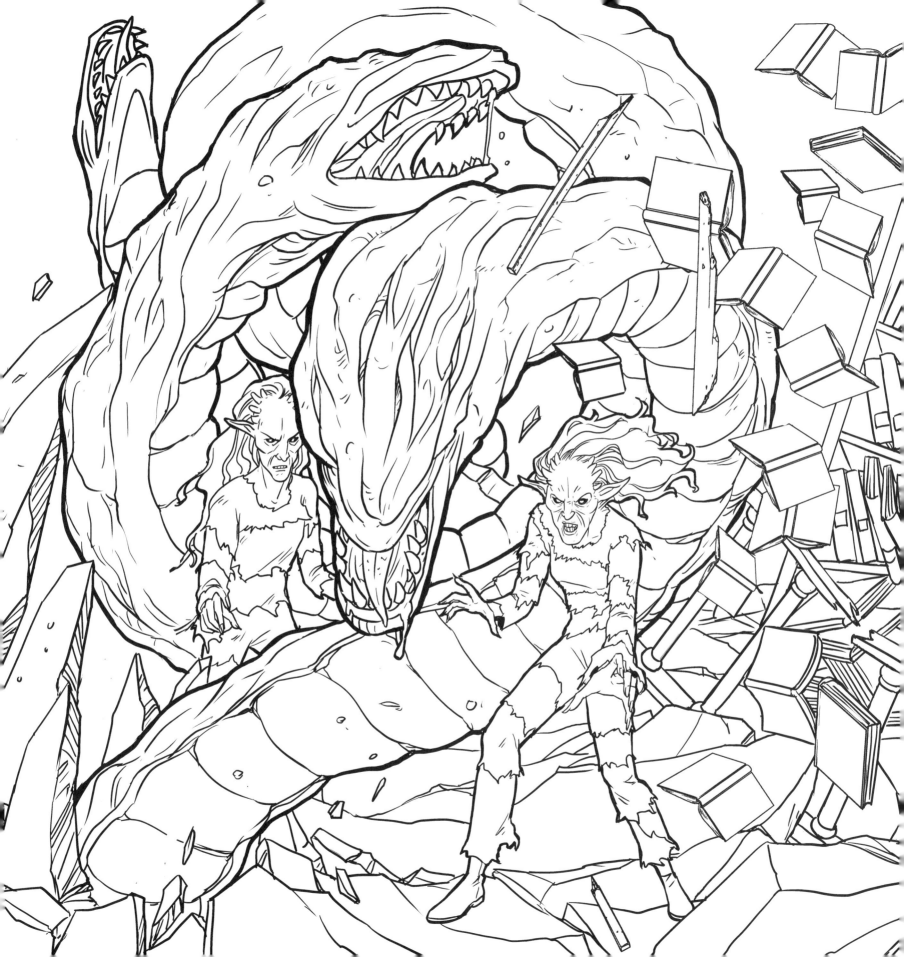

Giles: Buffy, I know it's horrible, but if you're going to hunt this creature, you should study it.

Buffy: Think I got it.

Willow: She's right. I mean, you've seen one big hairy bringer of death, you've seen 'em all.

Wesley: If I'm not mistaken, this is a hellhound.

Giles: Yes. It's particularly vicious. It's sort of a demon foot soldier bred during the Machash Wars. Trained solely to kill. They feed off the brains of their foes.

—Season 3, "The Prom"

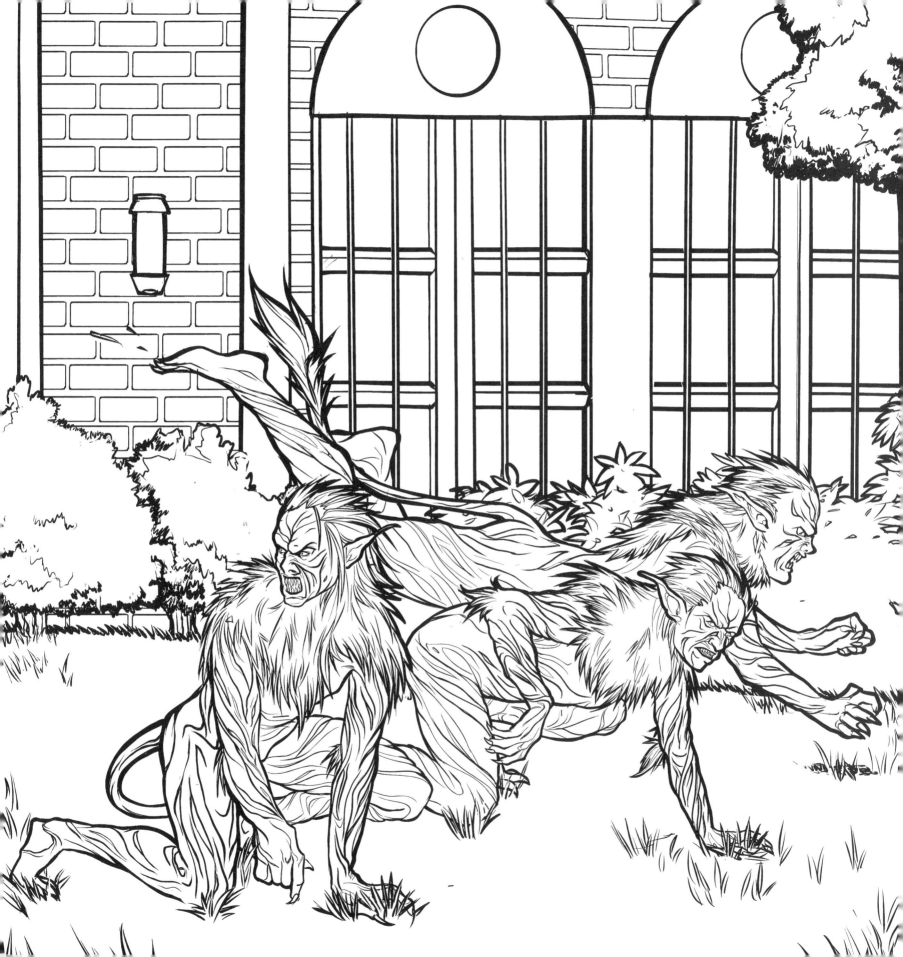

Angel: Am I a thing worth saving, huh? Am I a righteous man? The world wants me gone!

Buffy: What about me? I love you so much . . . And I tried to make you go away . . . I killed you and it didn't help . . . And I *hate* it! I hate that it's so hard . . . And that you can hurt me so much. I know everything that you did, because you did it to me. God. I wish that I wished you dead. I don't. *I can't.*

Angel: Buffy, please. Just this once . . . Let me be strong.

Buffy: Strong is fighting! It's hard, and it's painful, and it's every day. It's what we have to do. And we can do it together.

—Season 3, "Amends"

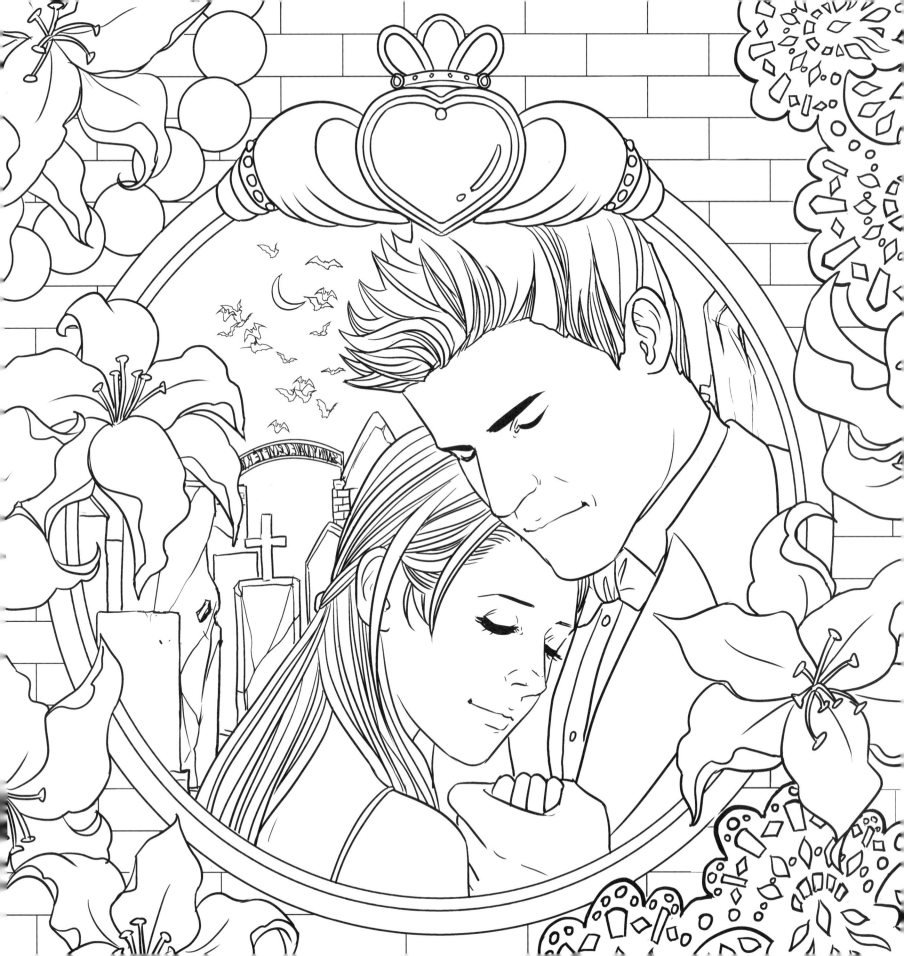

Giles: Harmony, where's Spike? Does he have the gem?

Harmony: He staked me and then he took it. He tried to take it right off my finger—like I wouldn't have just given it to him. I would have given him anything he wanted; he was my platinum baby and I loved him.

—Season 4, "The Harsh Light of Day"

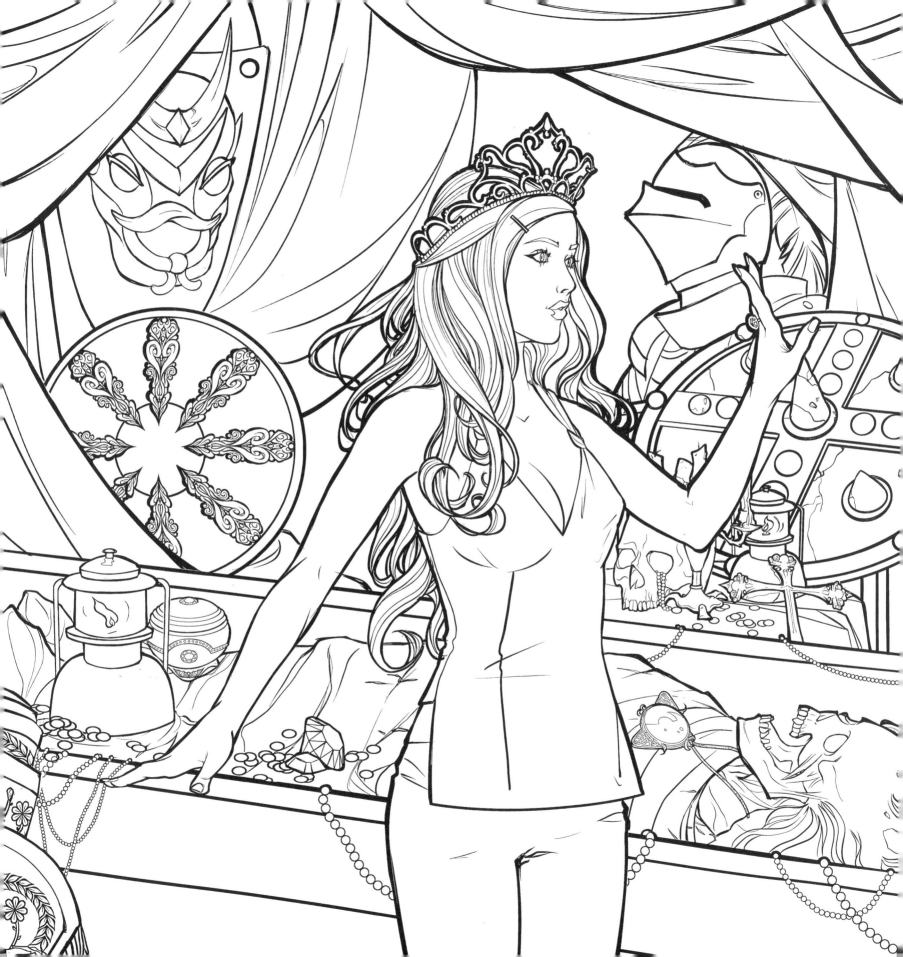

Buffy: This is Gachnar?

Xander: Big overture, little show.

Gachnar: I am the dark lord of nightmares, the bringer of terror. Tremble before me! Fear me!

Willow: He-he's so cute.

Gachnar: Tremble!

Xander: Who's a little fear demon? Come on. Who's a little fear demon?

Giles: Don't taunt the fear demon.

Xander: Why? Can he hurt me?

Giles: No, it's just tacky.

—Season 4, "Fear Itself"

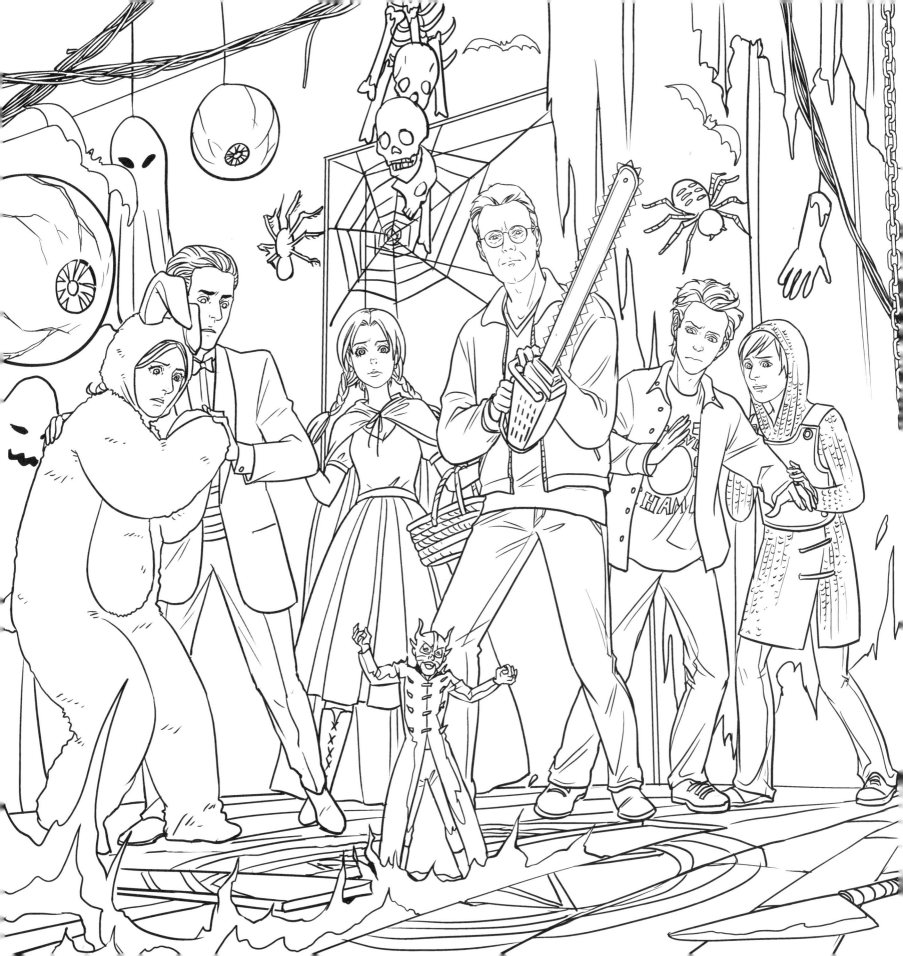

Oz: Don't touch her again.

Veruca: Come stop me. I like it rough, remember?

Oz: You wanna hurt me, hurt me. You leave her out of this.

Veruca: How can I? She's the reason you're living in cages. She's blinding you. When she's gone, you'll be able to admit what you are.

Oz: You don't wanna find out what I am.

Veruca: You're an animal. Animals kill.

Oz: You're right. We kill.

—Season 4: "Wild At Heart"

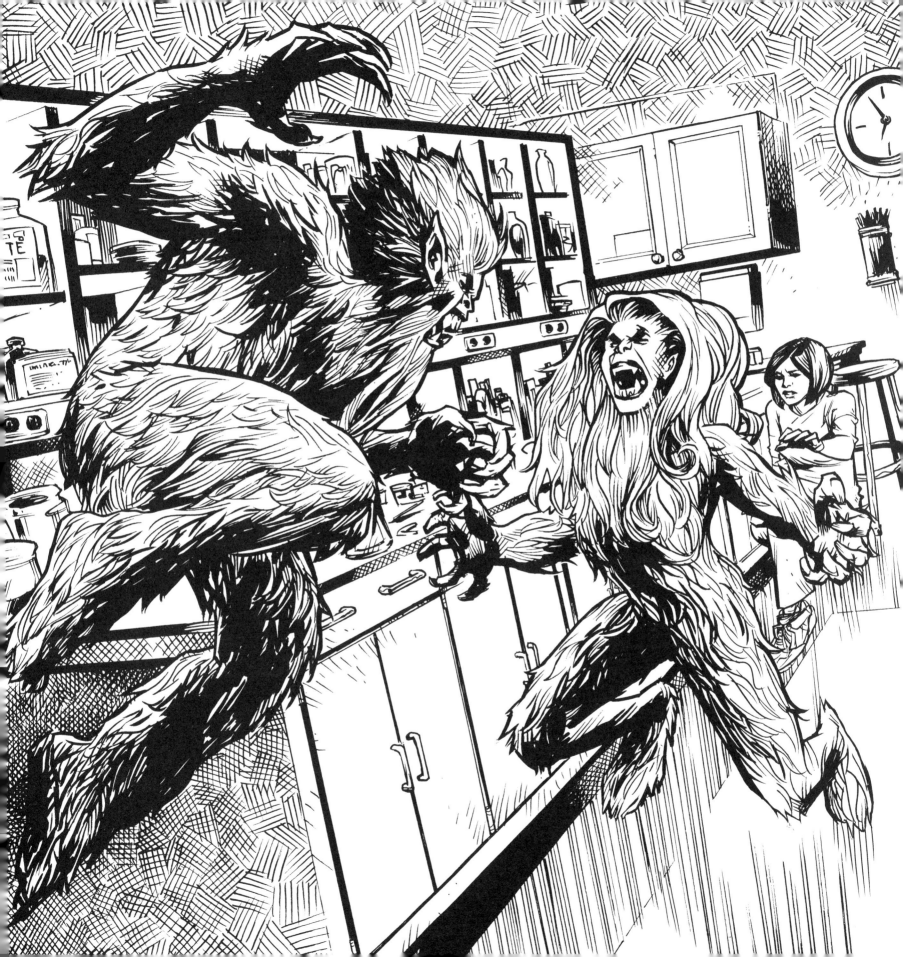

Hus, Chumash Warrior: You can't stop me.

Buffy: You're very wrong about that.

Hus: Yaugh! I am vengeance. I am my people's cry. They call for Hus, for the avenging spirit to carve out justice.

Buffy: They tell you to start an ear collection?

Hus: You slaughtered my people. Now you kill their spirit. This is a great day for you.

—Season 4, "Pangs"

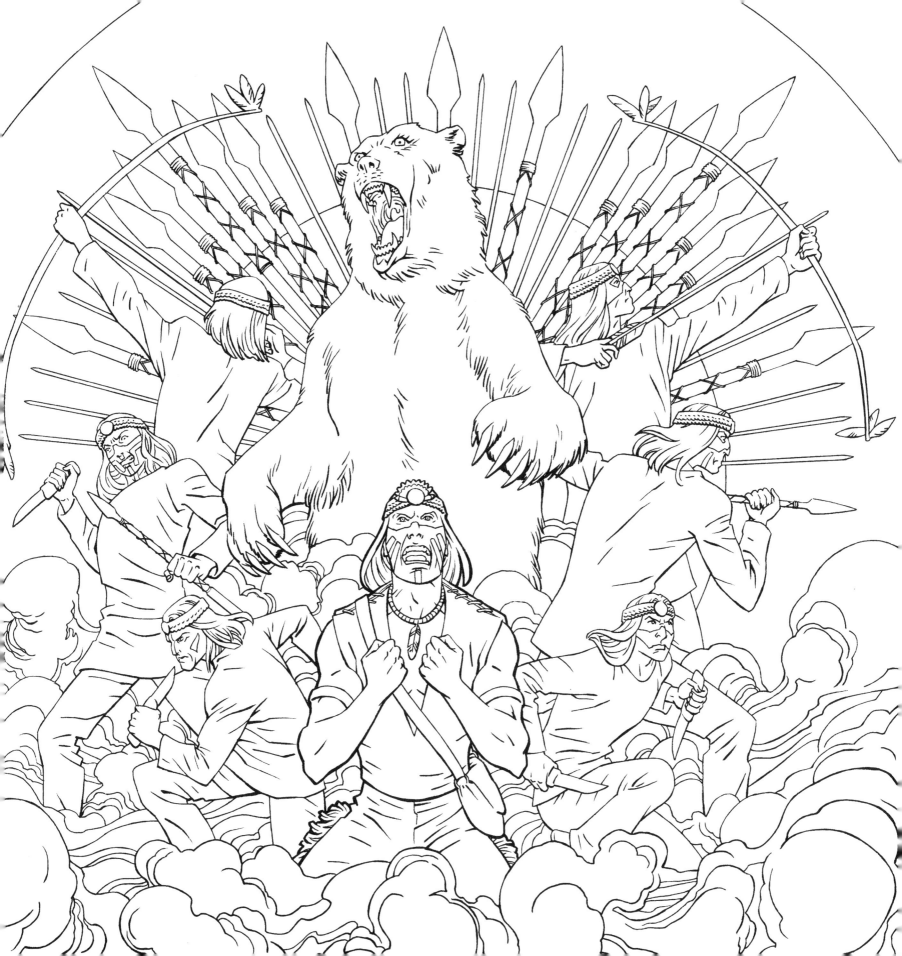

Buffy: You know what? I don't think you want us to let you go. Maybe we made it a little too comfy in here for ya.

Spike: Comfy? I'm chained in a bathtub drinkin' pig's blood from a novelty mug. Doesn't rate huge in the Zagat's guide.

Buffy: You want something nicer? Look at my poor neck. All *bare* and *tender* and *exposed*. All that blood just *pump*ing away.

Spike: Giles, make her stop!

—Season 4, "Something Blue"

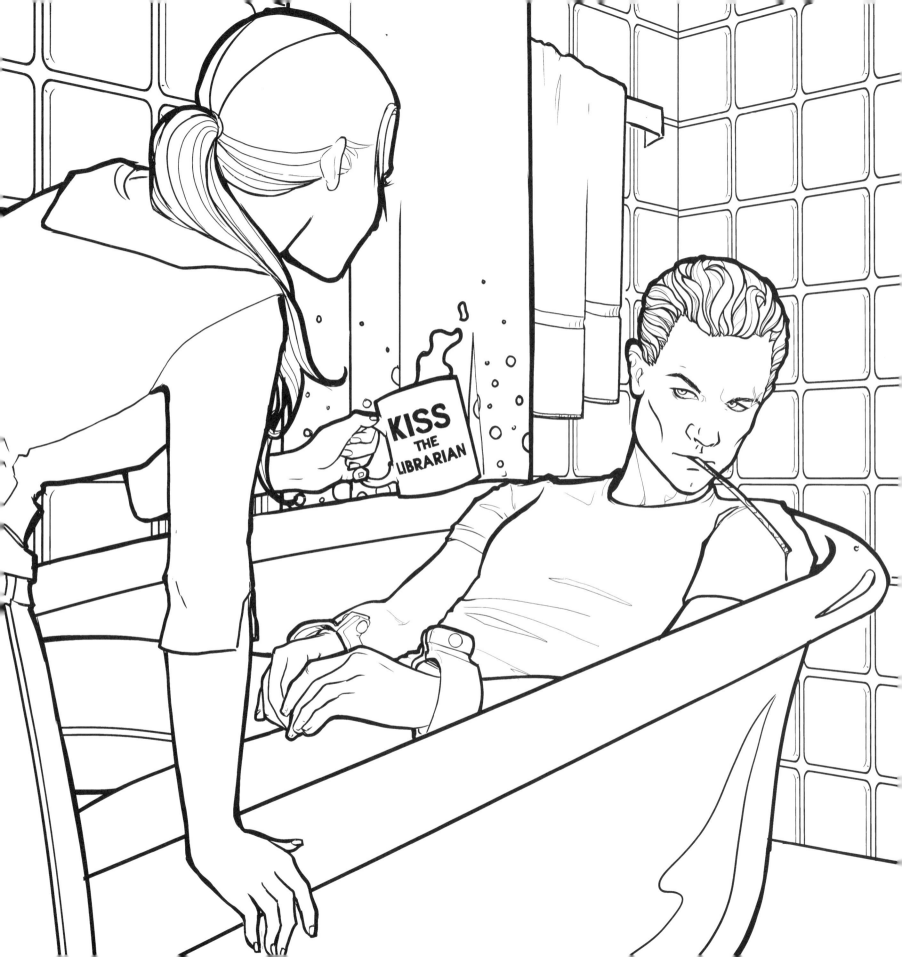

Can't even shout
Can't even cry
The gentlemen are coming by
Looking in windows
Knocking on doors
They need to take seven
And they might take yours
Can't call to mum
Can't say a word
You're gonna die screaming
But you won't be heard
 —Season 4, "Hush"

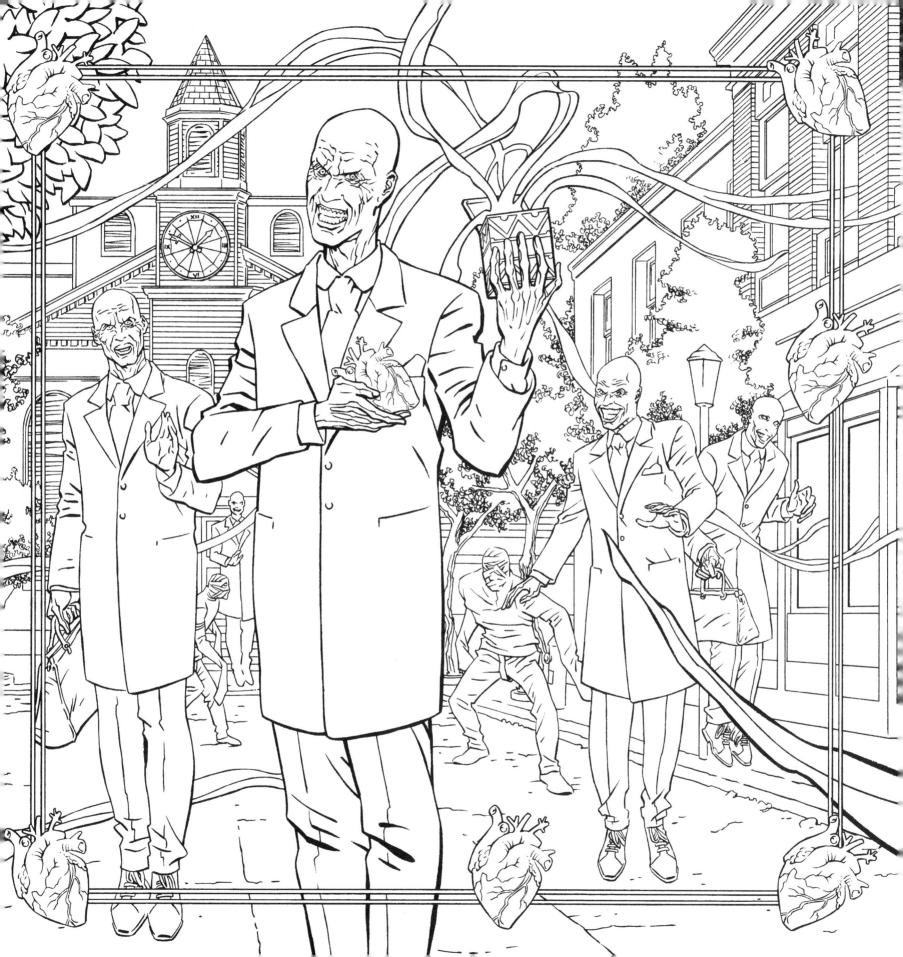

Spike: Giles?

Giles: Go on, then. Let's get on with the fighting—You understand me?

Spike: Of course I understand you.

Giles: I'm speaking English?

Spike: No, you're speaking Fyarl. I happen to speak Fyarl. And . . . by the way, why the hell are you suddenly a Fyarl demon? You just come over all demon-y this morning?

Giles: As a matter of fact, I did. Thanks to Ethan Rayne. You have to help me find him. He must undo this and then he needs a . . . good being killed.

Spike: And I'm just supposed to help you out of the evilness of my heart?

Giles: Y-you help me and I-I don't kill you.

Spike: Oh, tremendously convincing. Try it again without the stutter.

Giles: Money. I could pay you money.

Spike: Oh, I like money. How much?

—Season 4, "A New Man"

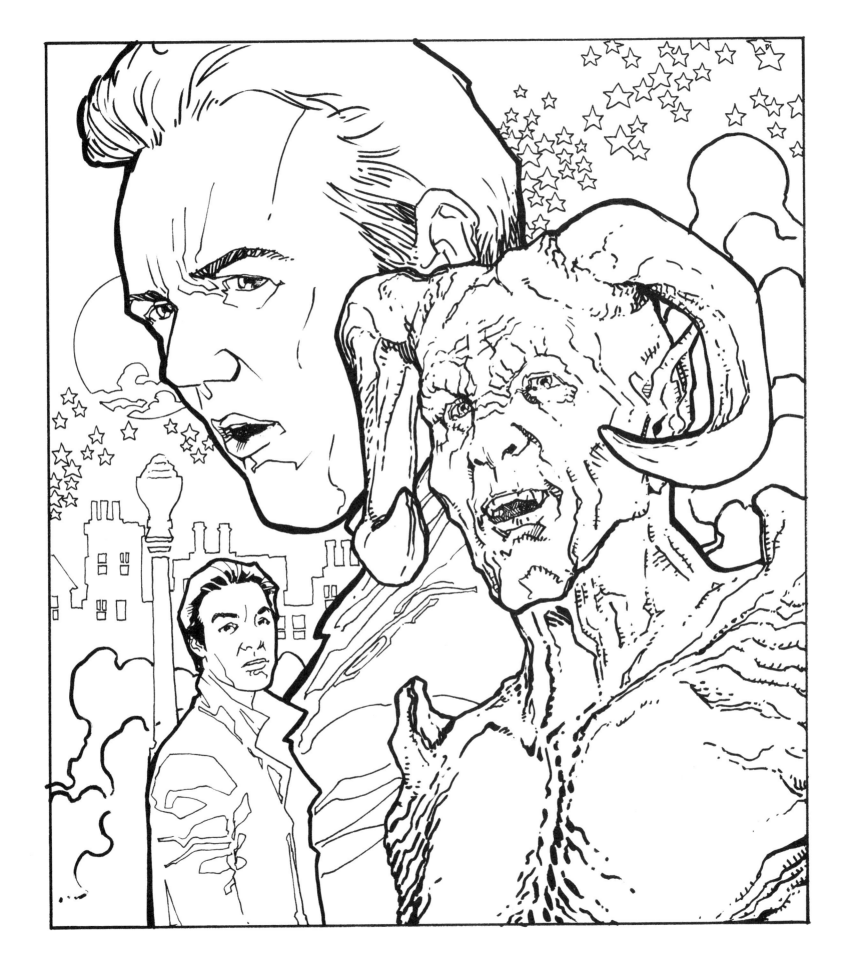

Adam: I'm a kinematically redundant, bio-mechanical demonoid designed by Maggie Walsh. She called me Adam, and I called her mother.

Dr. Angleman: Adam . . . Maggie would want you to stand down.

Adam: Yes, but I seem to have a design flaw. In addition to organic material, I'm equipped with GP2D11 infrared detectors, a harmonic decelerator, plus DC servo . . .

Buffy: She pieced you together from parts of other demons.

Adam: And man, and machine . . . Which tells me what I am but not *who* I am.

—Season 4, "Goodbye Iowa"

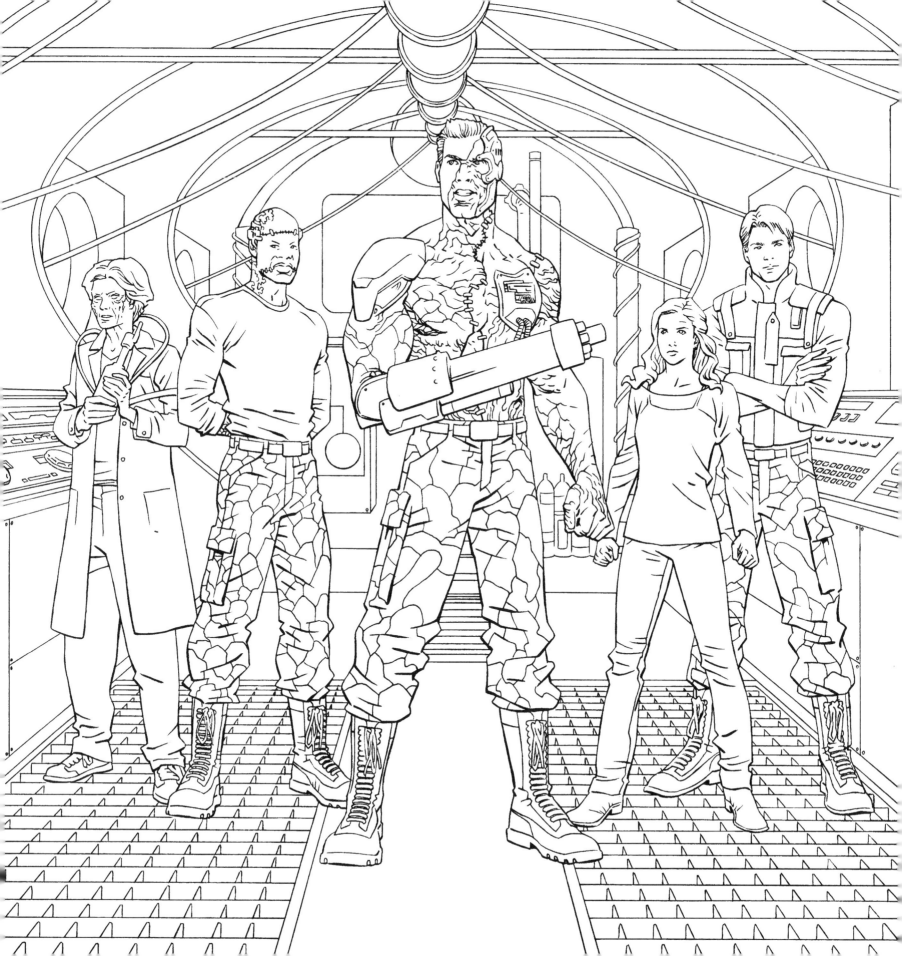

Buffy: There's no way around it. Faith is back and whether I like it or not she's my responsibility.

Willow: Yeah, too bad. That was the funnest coma ever.

Buffy: We have no idea where she is. And we don't know what she's thinking, what she's feeling.

Xander: Who she's doing.

Buffy: She could be terrified. Maybe she doesn't even remember? O-or maybe she does and, and she's sorry and she's alone, hiding somewhere?

Giles: Well perhaps there's some form of rehabilitation we just haven't thought about?

Willow: And if not, ass kicking makes a solid Plan B.

Buffy: I'm not gonna rule it out. First thing, we need to *find* her. Then we can take it from there.

Riley: Who's Faith?

—Season 4, "This Year's Girl"

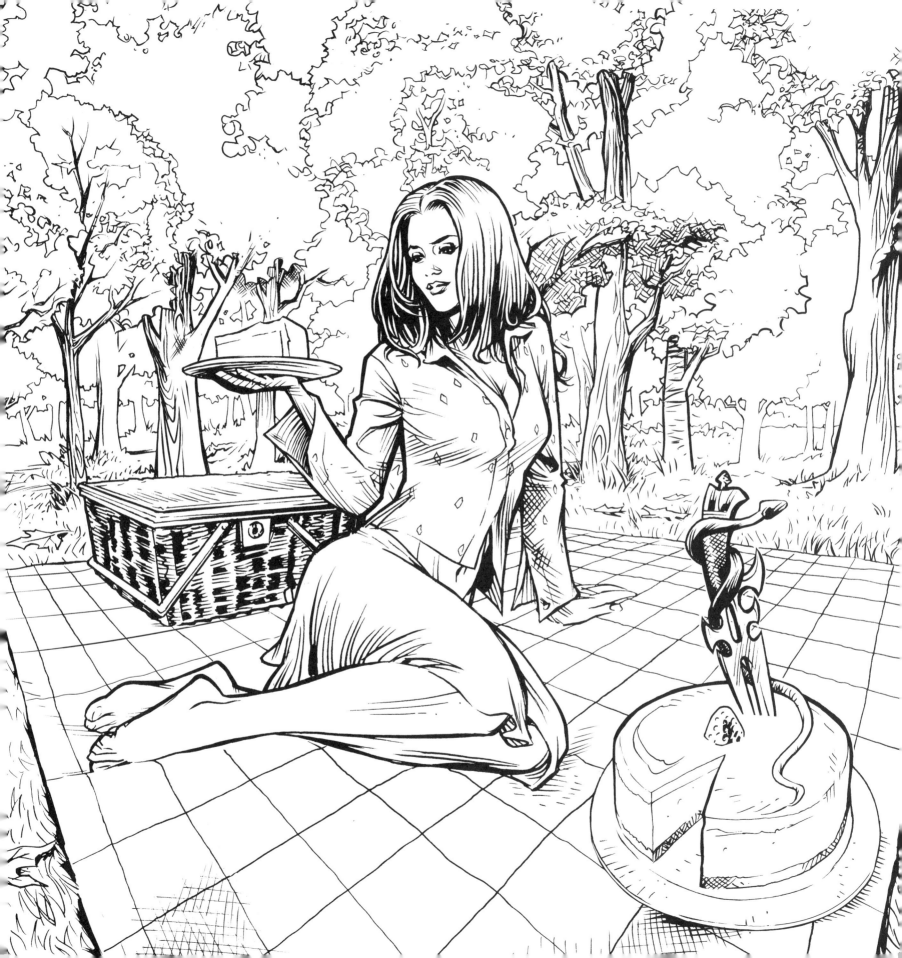

Buffy: I'm not entirely sure that we can trust our memories. Anya, tell them about the alternate universes.

Anya: Oh. Okay. Say you really like shrimp a lot. Or we could say you don't like shrimp at all. "Blah, I wish there weren't any shrimp," you'd say to yourself—

Buffy: Stop! You're saying it wrong. I think that Jonathan may be doing something so that he's manipulating the world and we're all like his pawns—

Anya: Or prawns.

Buffy: Stop with the shrimp. I am trying to do something here.
 —Season 4, "Superstar"

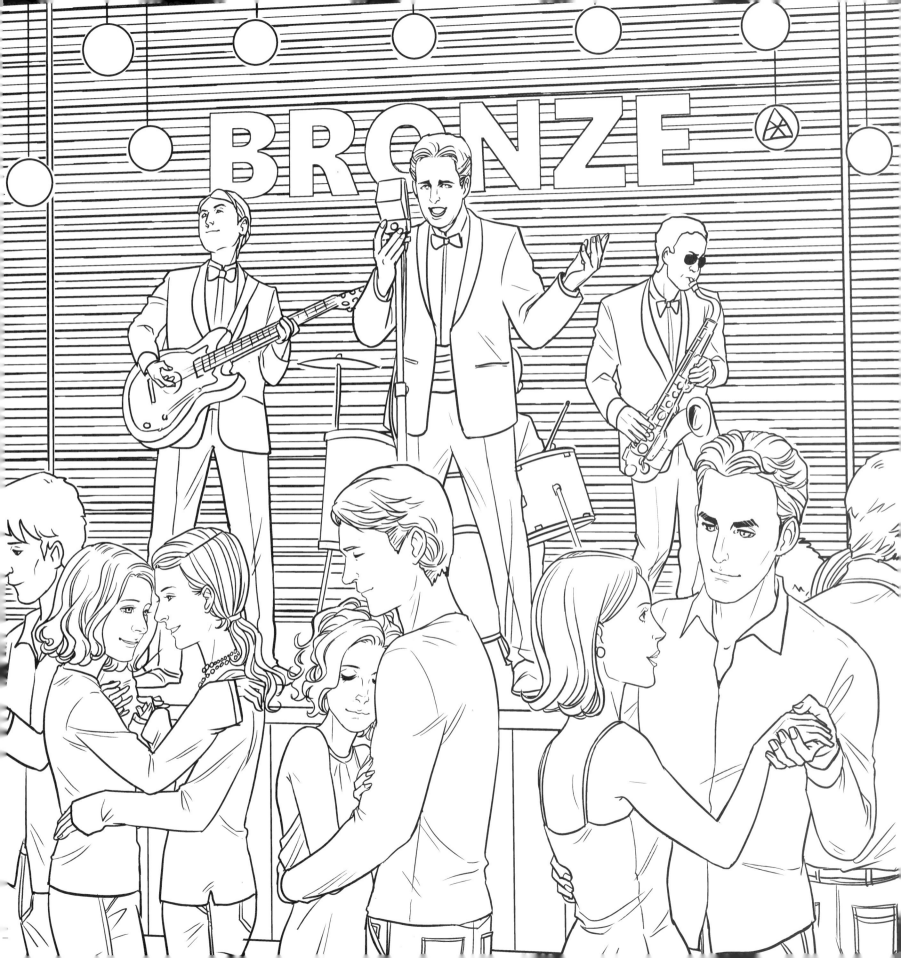

"You know, when you think about it, I'm the victim here. First off, I don't even want to be here. And I'm not talking about this room or this city or this state or this planet. I'm talking about the whole mortal coil now, you know? It's disgusting! The food . . . The clothes . . . The people. I could crap a better existence than this . . . But, okay—and feel free to tell me if this next part gets a little too personal, because I'm told I have boundary issues—but I'm hurt! Yes, by your incredibly selfish behavior. Newsflash, hairdo: It's not always about you. All I want is the Key! Why? Why can't you tell me where the Key is? . . . Oh! Forgive me . . . monk-y. Sometimes I just . . . I get so anxious—like there's something deep inside of me and it's swelling up and it's making me crazy!—that I forget there's all that duct tape on your face!"
— Glory, Season 5, "No Place Like Home"

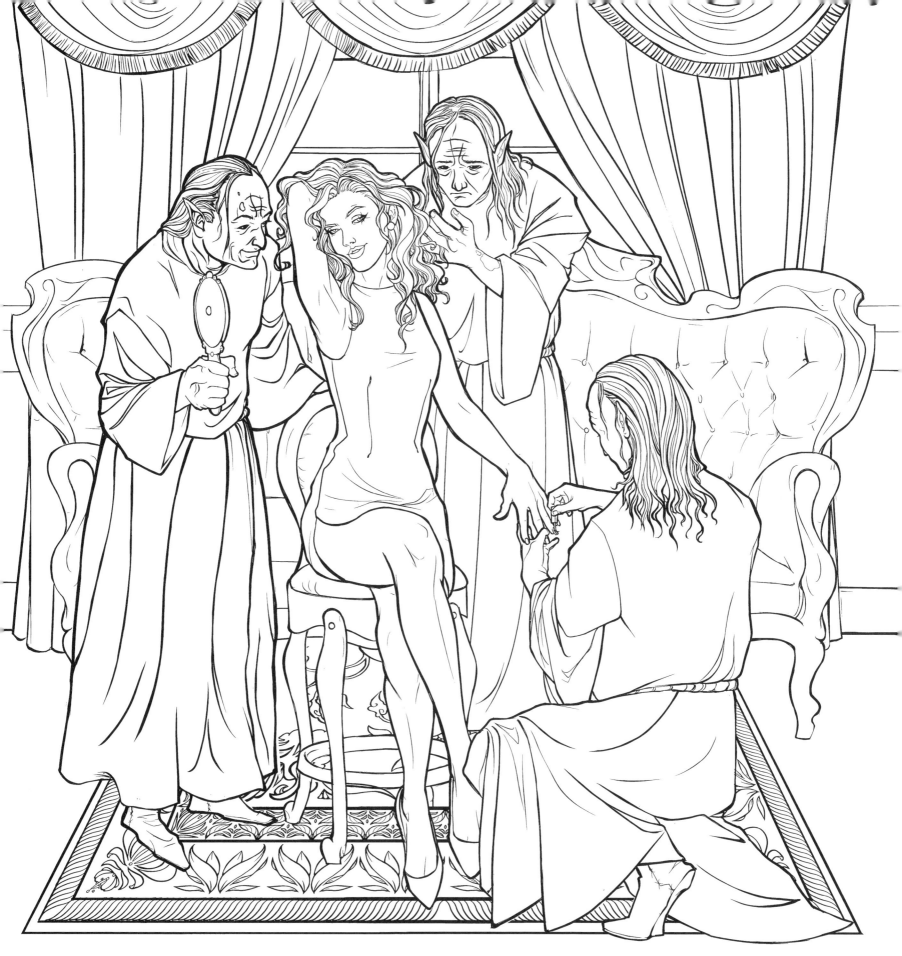

Buffy: Who are you?

Dracula: I apologize, I assumed you knew. I'm Dracula.

Buffy: Get *out*!

—Season 5, "Buffy vs. Dracula"

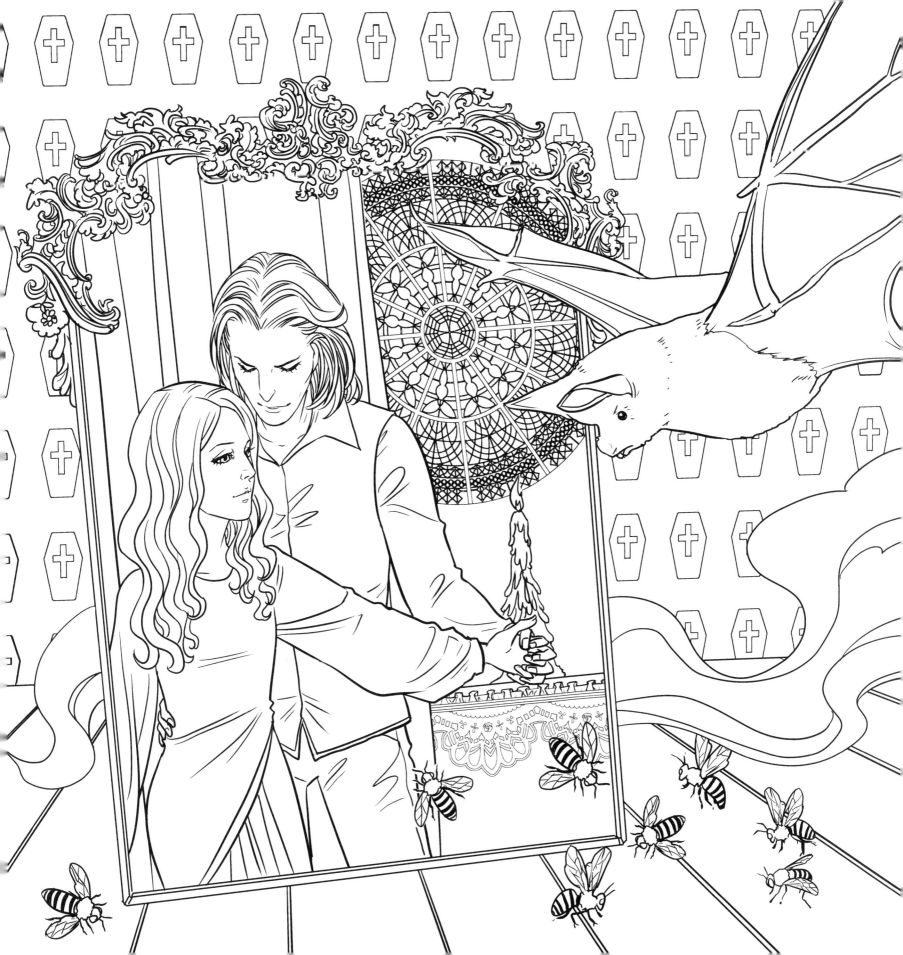

Buffy: Okay. Let's see what you are . . . Or who you are.

Knight: One soldier in a vast army.

Buffy: What army?

Knight: The Knights of Byzantium, an ancient order. And now your enemy.

Buffy: You work for Glory?

Knight: You think we align ourselves with the beast? You must be mad.

Buffy: You're the ones tried killin' me.

Knight: No, we were fools, three alone. But if it takes a hundred men, we send a hundred men, and if it takes a thousand, we send a thousand.

Buffy: A thousand?

Knight: So long as you protect the key, the brotherhood will never stop until we destroy it and you. You are the Slayer, and we know what we must do. Now, be done with it. Kill us, and let legions follow.

—Season 5, "Checkpoint"

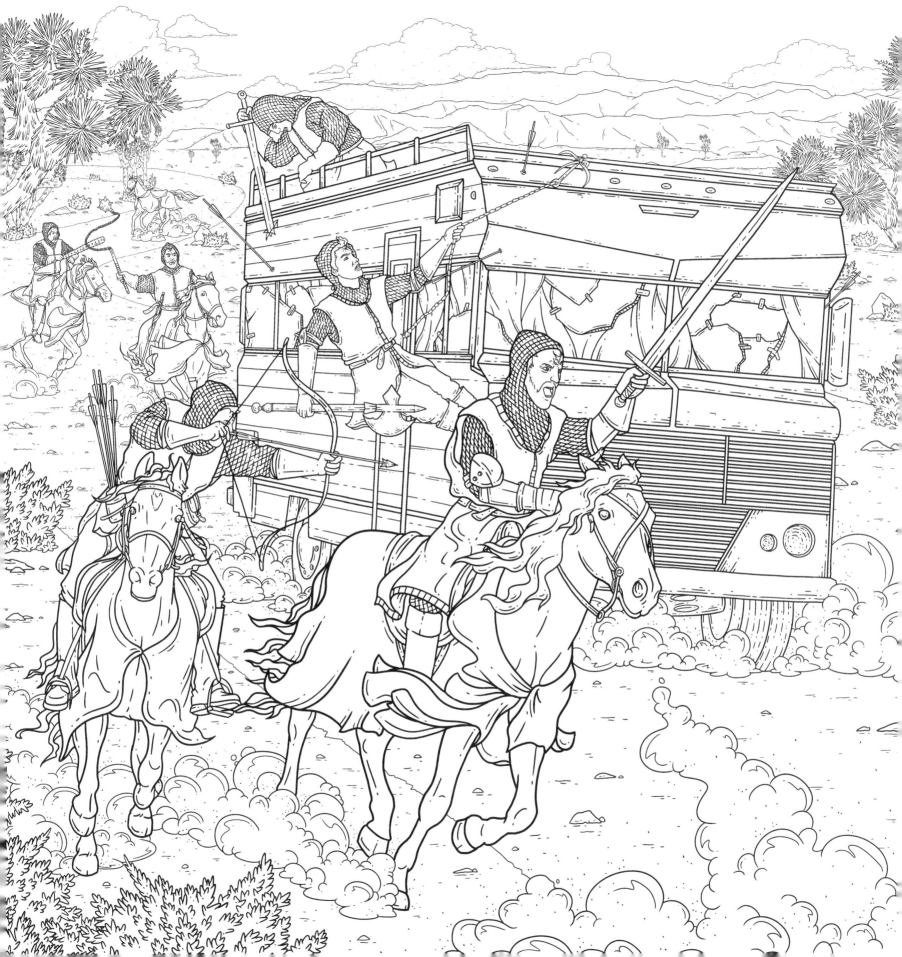

Razor: You tellin' me there's no Slayer in Sunnydale?

Vampire: That's what I'm saying, they got some kind of decoy standing in for her.

Mag: Nowhere like the Hellmouth for a party. There's all kinds of bad in that place.

Vampire: I guess with your muscle, uh, you could own it in no time. Hey, look, I know you guys don't usually let vampires join the gang, and I got the whole "sunlight" issue. But I was thinking, you know, as thanks for the four-one-one, you could let me go—

Razor: I'll think it over.

Razor: Let's ride!

—Season 6, "Bargaining"

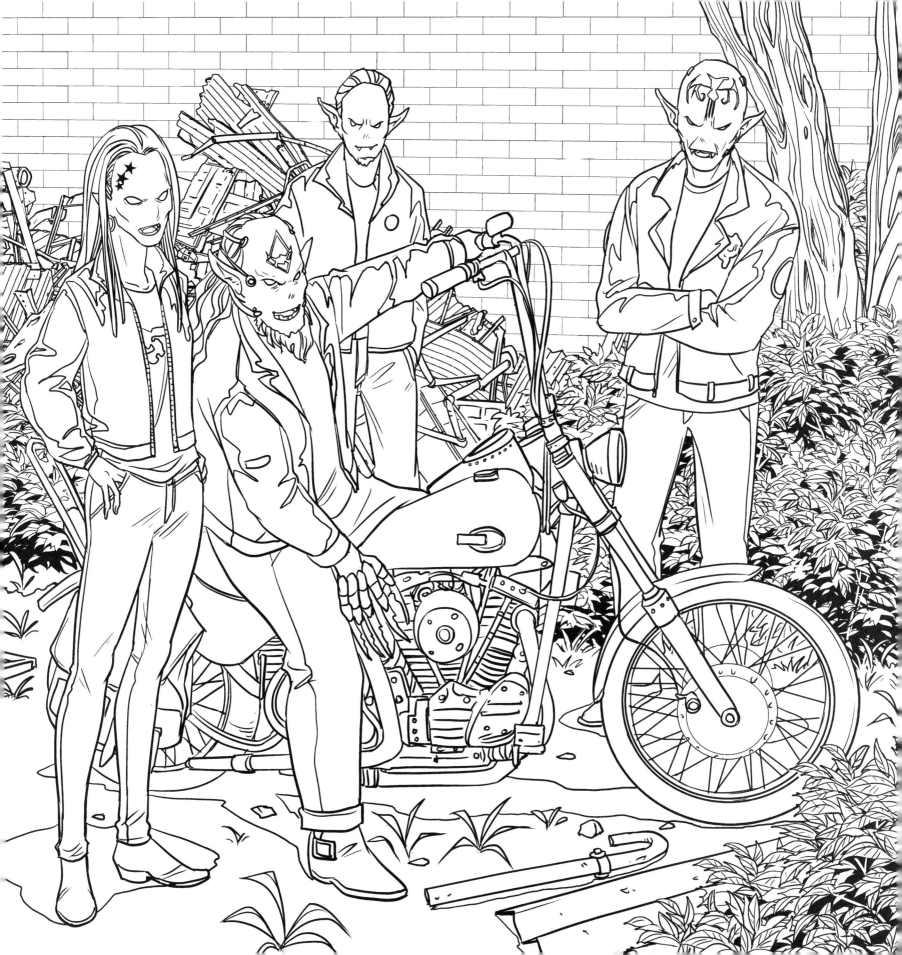

Buffy: Uh, so, did anybody . . . uh . . . last night, you know, did anybody, um . . . burst into song?

Xander: Merciful Zeus!

Willow: We thought it was just us!

Giles: Well, I sang but I had my guitar at the hotel . . .

Tara: It was bizarre. We were talking and then it was like—

Buffy: Like you were in a musical!

Tara: Yeah!

Giles: That would explain the huge backing orchestra I couldn't see and the synchronized dancing from the room service chaps.

Willow: We did a whole duet about dish washing.

Anya: And we were arguing and, and then everything rhymed and there were harmonies and the dance with coconuts.

Willow: There was an entire verse about couscous.

Xander: It was very disturbing.
> —Season 6, "Once More with Feeling"

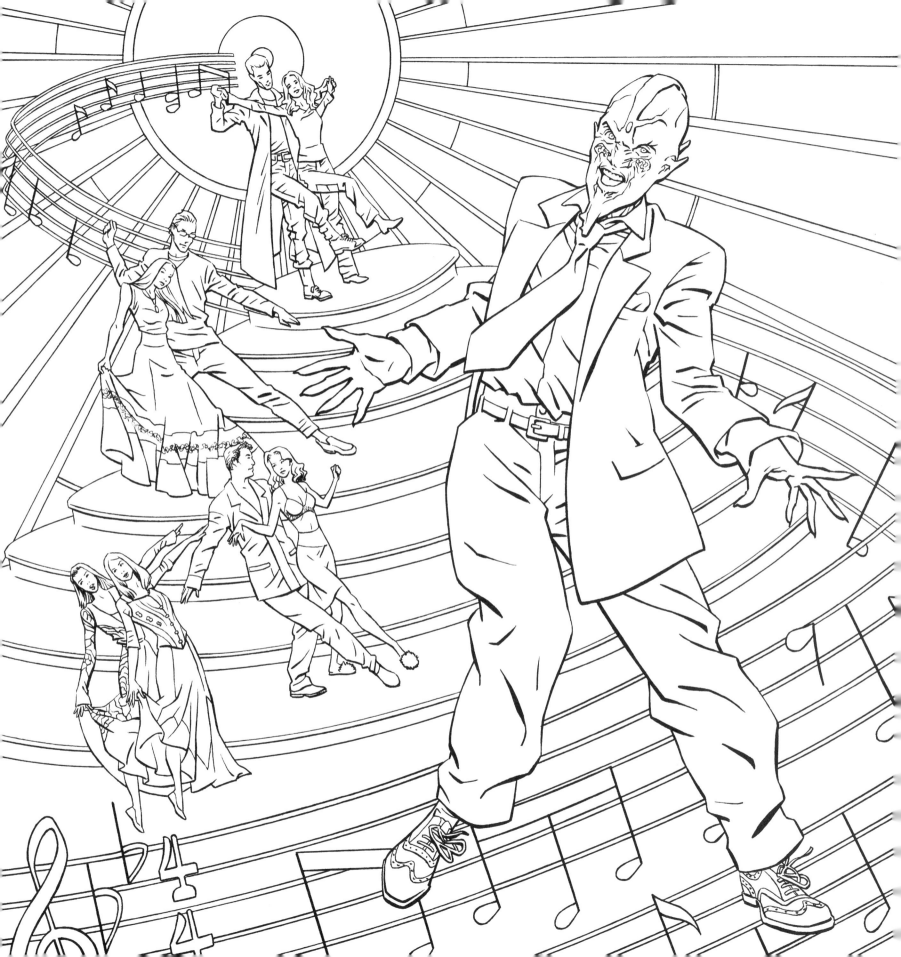

Buffy: There's something keeping us in this house.

Xander: Or someone.

Tara: Has everyone tried to get out?

Willow: What if we just, like, as a group, got up and, and threw ourselves at the door?

Xander: All right. Count of three. One . . . two . . . three!
—Season 6, "Older and Far Away"

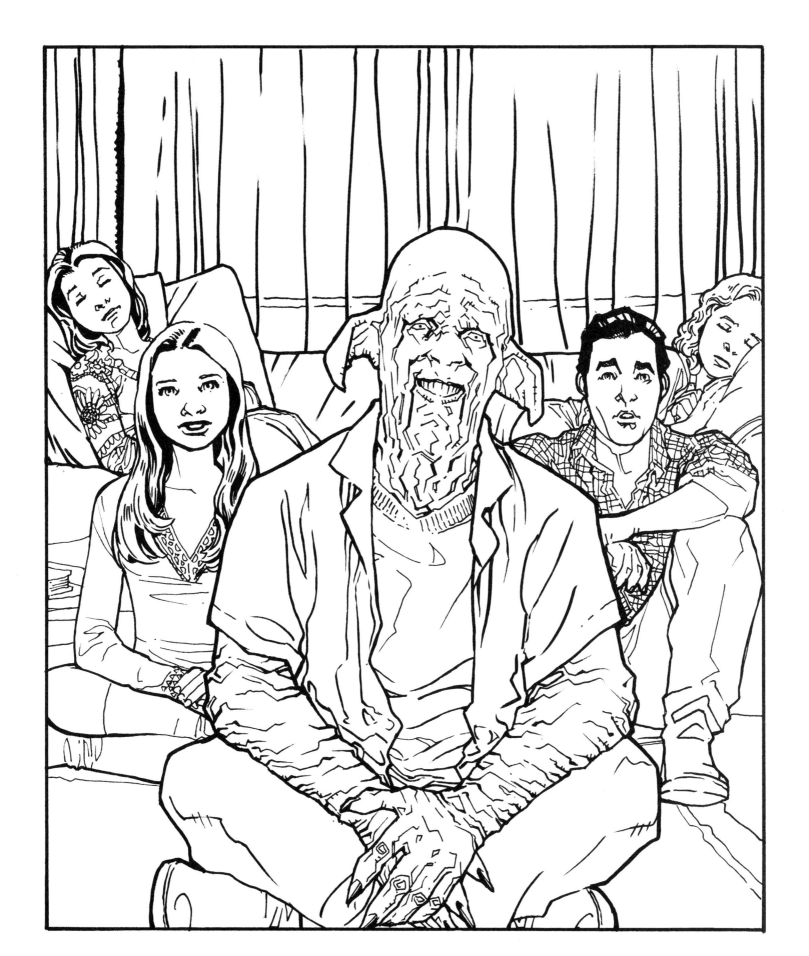

Riley: Sam and I have been tracking a Suvolte demon through Central America. Killing machine. Nearly mature.

Sam: Yeah, three months old and growing fast.

Riley: These things start to kill the minute they're hatched. And leave a real clear trail.

Sam: Yeah. Just follow the villages with nothing in them but body parts.

Dawn: So, this demon shredded your guys, and now you're looking for a little payback?

Sam: No. It came here to the Hellmouth to, to spawn. But we think it already hatched its eggs somewhere.

Riley: And the plan was to track it. Let the demon take us to its nest.

Dawn: And . . . now they're gonna hatch a bunch of . . . baby demon things?

Sam: Unless we stop it.

Buffy: Which means we have to find the nest, and fast, before Sunnydale turns into the Trouble Meat Palace.

—Season 6, "As You Were"

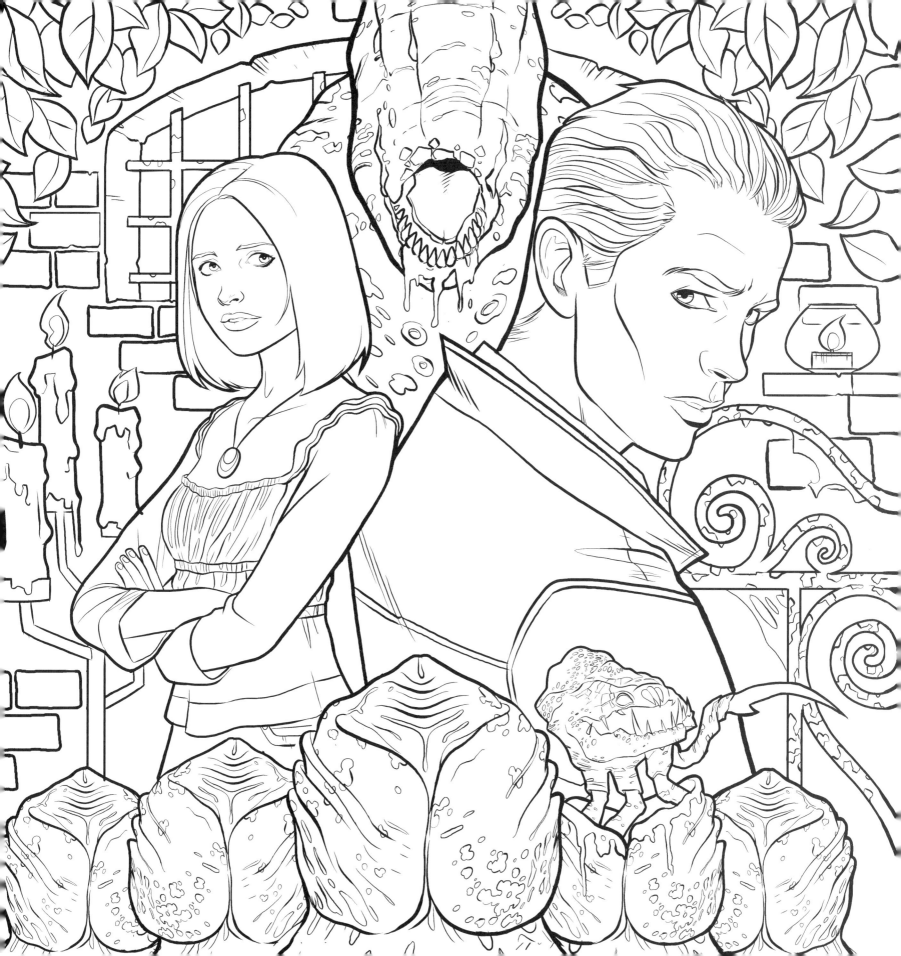

Anya: Sorry. I know. I'm just distracted.

Halfrek: What? About this thing with Xander? Don't worry, you'll find a way to—

Anya: That's just it! I've tried everything. I've tried every curse I knew. Nothing's worked.

Halfrek: Wait, did you try to curse him yourself?

Anya: I am the wronged party here. Of course—

Halfrek: So you can't exact justice on someone on behalf of yourself, silly. How long you been away?

Anya: But—I haven't been scorned by a man in, like, a thousand years. I've never had to make a wish for myself. There has to be some way around that.

Halfrek: Well, you could try getting someone to make the wish for you . . . I s'pose.

—Season 6, "Entropy"

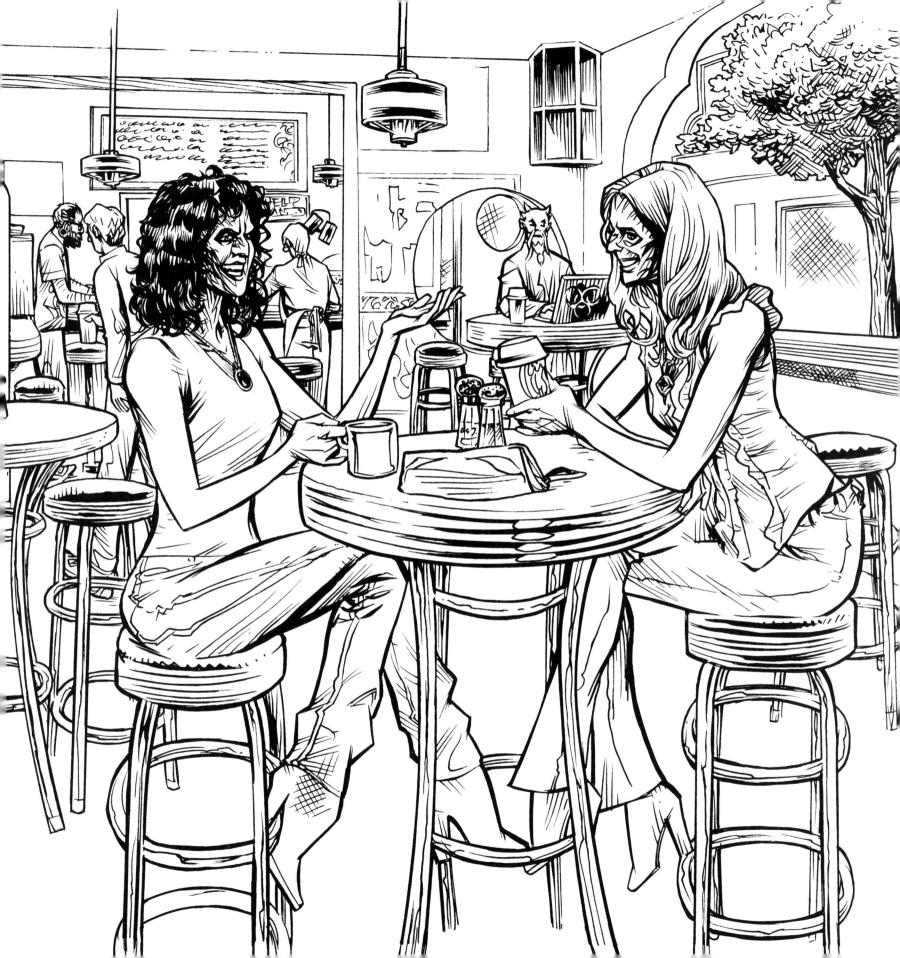

D'Hoffryn: I'm afraid you don't see your true self. You are Anyanka. I'm a patron of a family of sorts. We're vengeance demons. I'm sure you've heard of us.

Anya: No, I'm sorry.

D'Hoffryn: I get the sense that your talents are not fully appreciated here, Anyanka. We'd like you to join us.

Anya: Why do you keep calling me that? My name is Aud.

D'Hoffryn: Perhaps, but Anyanka is who you are.

Anya: What would I have to do?

D'Hoffryn: What you do best. Help wronged women punish evil men.

Anya: Vengeance.

D'Hoffryn: But only to those who deserve it.

Anya: They all deserve it.

D'Hoffryn: That's where I was going with that, yeah.

—Season 7, "Selfless"

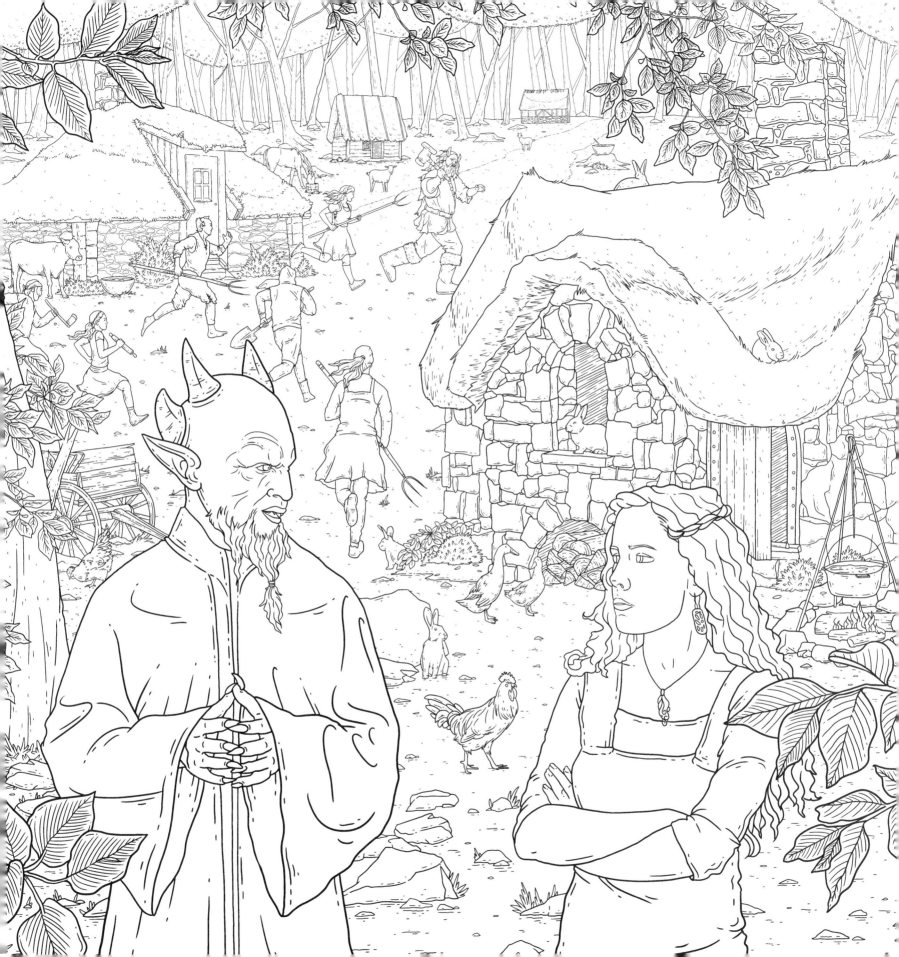

"When I say 'I love you,' it's not because I want you, or because I can't have you. It has nothing to do with me. I love what you are, what you do, how you try. I've seen your kindness and your strength. I've seen the best and the worst of you. And I understand with perfect clarity exactly what you are. You're a hell of a woman. You're the one, Buffy."

—Spike, Season 7, "Touched"

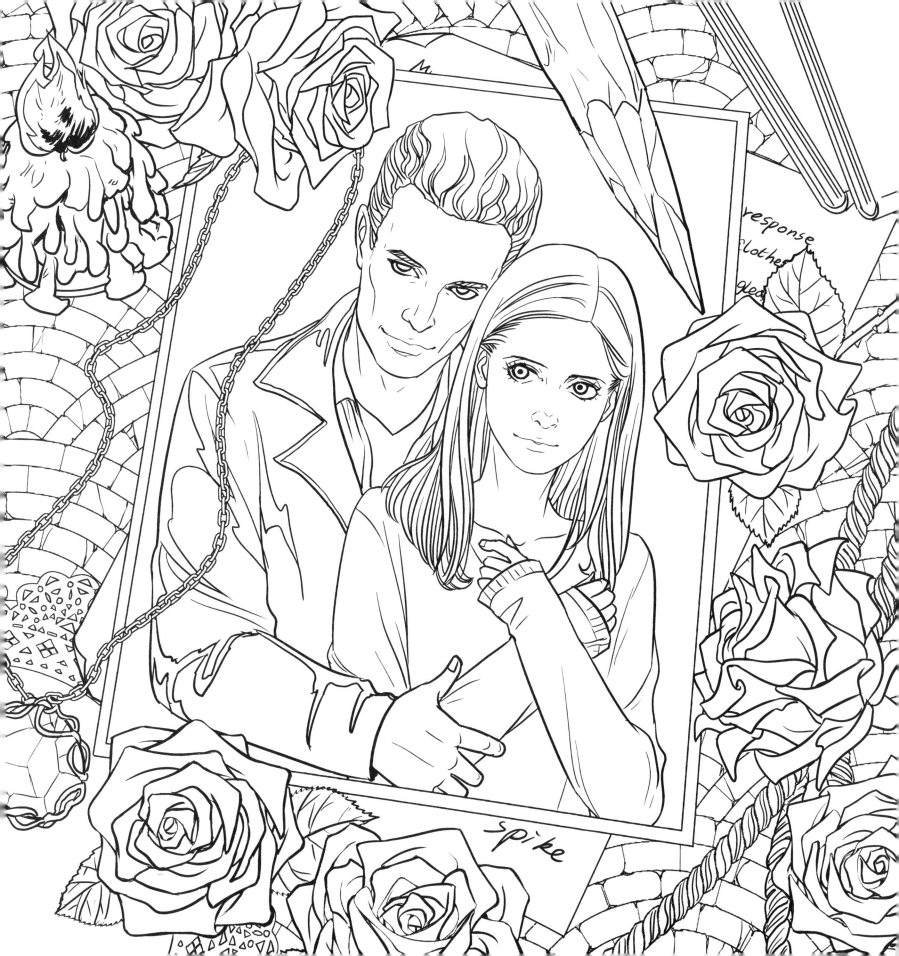

"What can I say? I work in mysterious ways . . . Also some fairly straightforward ones."

<div style="text-align: right">—Caleb, Season 7, "Dirty Girls"</div>

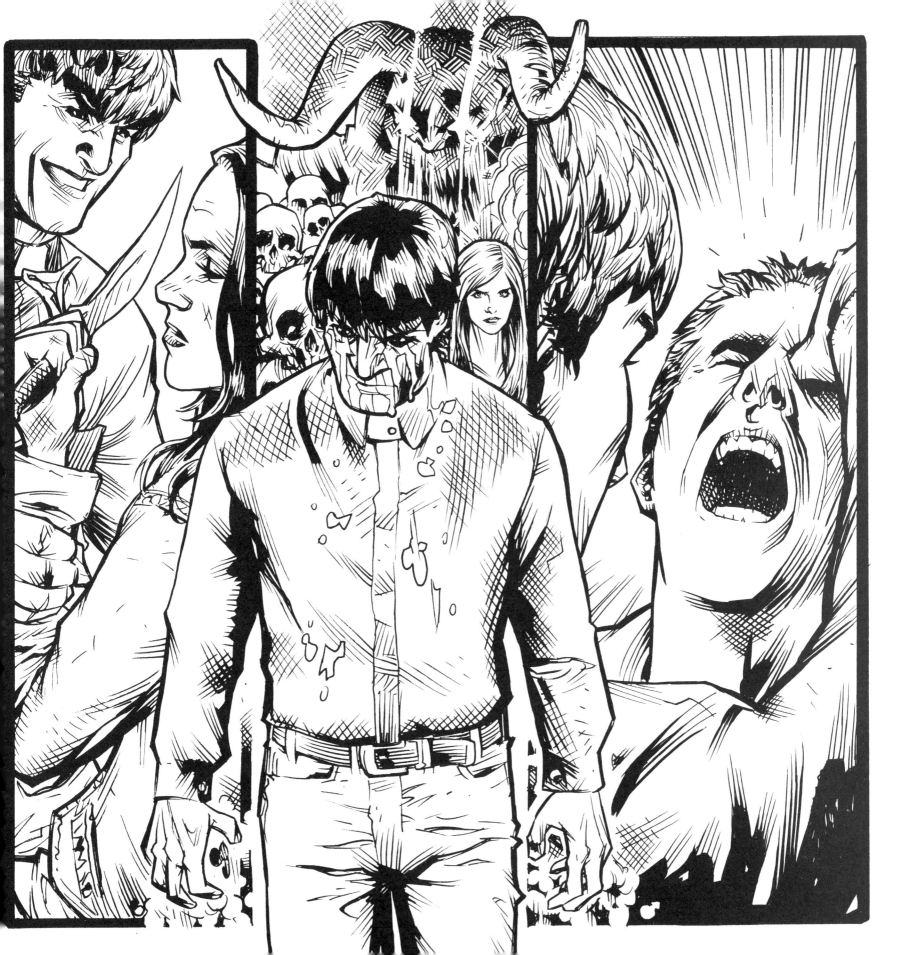

"As Neanderthals are to human beings, the Turok-Han are to vampires. Primordial, ferociously powerful killing machines, as single-minded as animals. They are the vampires that vampires fear. An ancient and entirely different race. And, until this morning, I thought they were a myth."

—Giles, Season 7, "Bring On the Night"

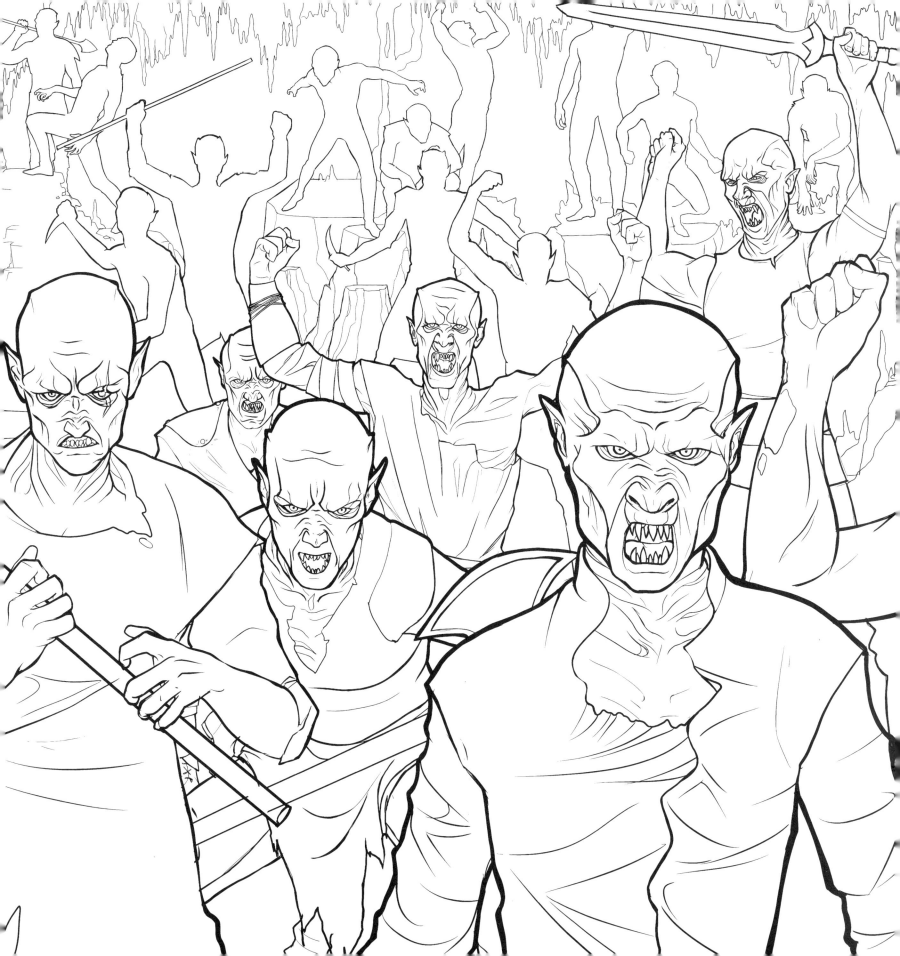

Kennedy: It's a what?

Research Slayer: A Vampy Cat!

Satsu: A who what now?

Research Slayer: Vampy Cat, the new Happy Cat variant. Pre-orders are through the roof, but it's not supposed to hit the market until next week. This one must be a prototype or something. Which explains the armored car.

Satsu: Vampires aren't cute and fluffy! And a kitty cat? Come on!

Kennedy: Since that idiot Harmony's reality show took off, everybody's obsessed with fangs and lumpy foreheads. Public's following their undead bull by the handful.

—Season 8, "Swell"

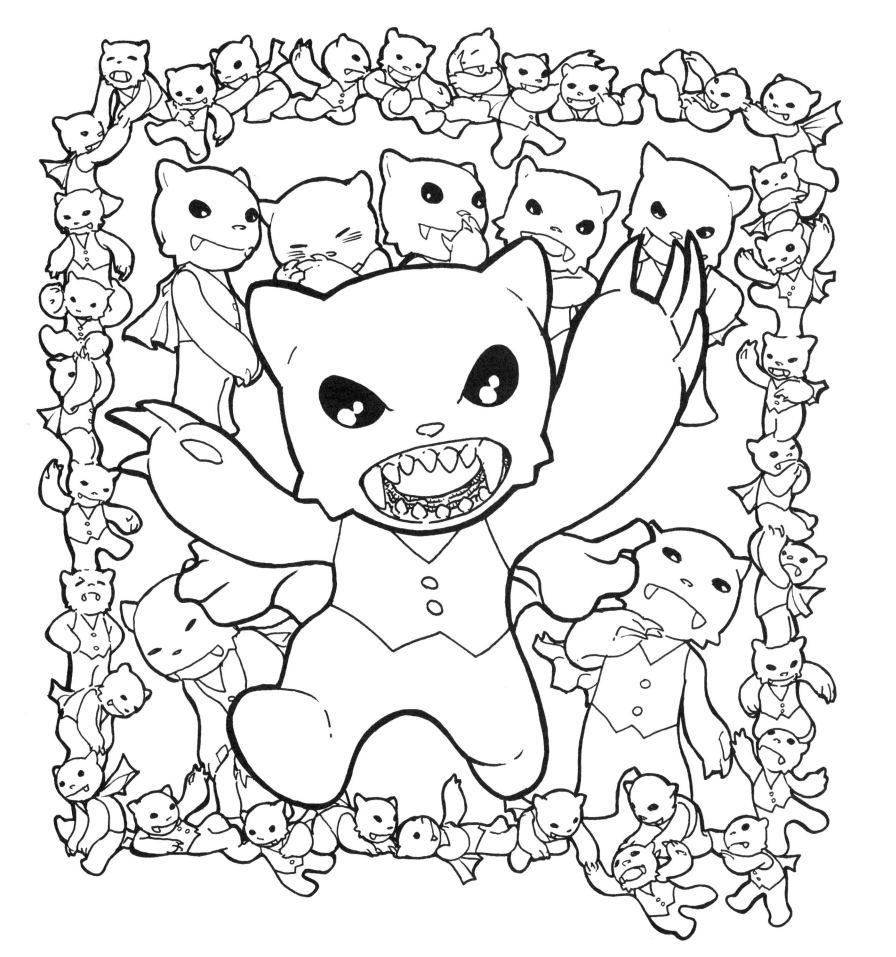

Twilight: One Slayer was all right, but all these girls . . . The world can't contain them, and they will suffer for that. I'll not kill you now. My first gift is my last. I know that you meant well. But you have brought about disaster. And it falls to me to avert it.

Buffy: Twilight. That's you.

Twilight: Have you made a difference? Have your Slayers helped change anything in this world? Have they helped you?
—Season 8, "A Beautiful Sunset"

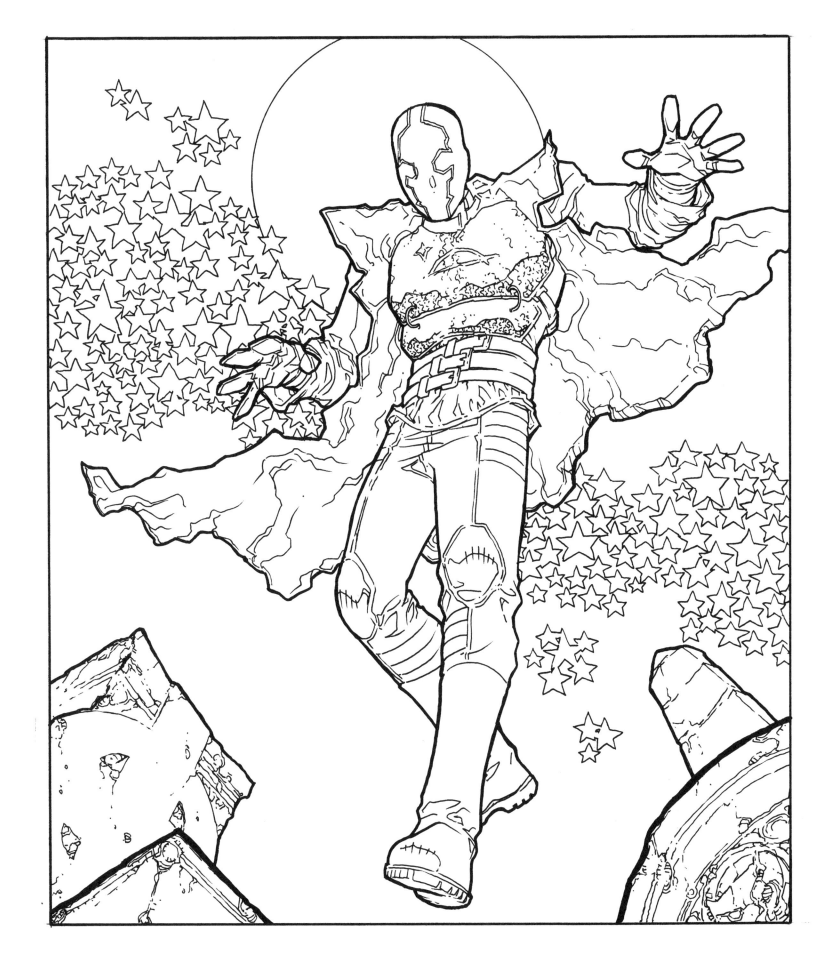

ABOUT THE ILLUSTRATORS

STEPHEN BYRNE *(pages 19, 77)*
Stephen Byrne was born in Dublin, Ireland. At age twelve he proclaimed to the world that he would be a comic artist when he grew up. He studied at the Irish School of Animation and has worked in movies, TV, video games, and comics. He now lives in London, where his best friend is his digital drawing stylus.

PABLO CHURIN *(pages 15, 17, 23, 31, 35, 51, 55, 59, 73)*
Pablo Churin was born in Argentina. After beginning his career as an artist for fanzines, his comics work began with a horror miniseries for Studio 407 called *Hybrid.* Some of Pablo's professional work includes *Agon* for Zenescope Entertainment, *El General San Martín* for Ovni Press, *Thief: Tales from the City* for Dark Horse Comics, *God Is Dead* for Avatar Press, and several web comics for MTJ Publishing.

NEWSHA GHASEMI *(pages 13, 21, 25, 27, 41, 45, 53, 65, 87)*
Newsha Ghasemi is a freelance illustrator raised in the outskirts of Washington, DC. She has had a love of illustration since she was a kid. With caffeine-driven ambition and a disregard for a human's need for sleep, she eventually developed a career out of art and garnered experience with various notable companies, such as Gree, DeNA, Koei Tecmo, Double Take Comics, and most recently, Dark Horse Comics.

GEORGES JEANTY *(pages 57, 75, 89, 91)*
Serenity and *Buffy the Vampire Slayer* artist Georges Jeanty studied fine arts at Miami Dade College; the pursuit of a career in comics was a logical choice for his artistic talents. He worked for DC Comics on titles such as *Green Lantern*, *Superboy*, and *Superman*. The year 2006 brought Georges the critically acclaimed comics miniseries *The American Way*, written by screenwriter John Ridley and released through WildStorm. Georges was handpicked by Joss Whedon to become the artist on *Buffy* Season 8, the Eisner Award winner for Best New Series in 2008. He continued as the regular series artist for *Buffy the Vampire Slayer* Season 9 and recently was the artist for the *Serenity: Firefly Class 03-K64* series, *Leaves on the Wind* and *No Power in the 'Verse*, before returning to *Buffy the Vampire Slayer* Season 11.

YISHAN LI *(pages 11, 37, 39, 43, 47, 63, 67, 71, 83)*

Yishan Li is a professional British comic/manga artist currently living in Shanghai. She has been drawing since 1998 and has been published internationally in the US, France, Germany, Italy, and the UK, among other countries. She has worked for publishers such as Random House, Del Rey, Titan, Delcourt, DC Comics, and Dark Horse Comics. Yishan is currently the artist for the *Buffy: The High School Years* graphic novels from Dark Horse Comics.

KARL MOLINE *(cover, pages 1, 5, 7, 9, 29, 33, 49, 61, 79, 85)*

Best known for his work in the *Buffy* universe, comic artist Karl Moline first worked with series creator Joss Whedon on the 2003 miniseries *Fray*, from Dark Horse Comics, set in the future of Buffy's world. With the return of *Buffy the Vampire Slayer* in comics with Season 8, Karl was brought in to draw a Buffy/Fray crossover arc, as well as single issues of Seasons 8, 9, and 10. Karl has also done work for other comics publishers, such as Marvel Comics (including *Avengers Academy*, *The Loners: The Secret Lives of Super Heroes*, *Spider-Man Unlimited*, *X-Factor*, and *X-Men*).

TAYLOR ROSE *(pages 69, 81)*

Taylor Rose lives, works, and plays in Bend, Oregon as a freelance illustrator and designer. When she is not making art you can find her traveling by snowboard, bicycle, and stand up paddle board. She loves fly fishing and has a somewhat healthy obsession with cartoons, hobbits, *Buffy the Vampire Slayer*, and owls. Taylor's art has also recently been featured in the *Serenity: Firefly Class 03-K64—Everything's Shiny Adult Coloring Book*.

ALSO FROM DARK HORSE BOOKS AND THE WORLD OF BUFFY THE VAMPIRE SLAYER . . .

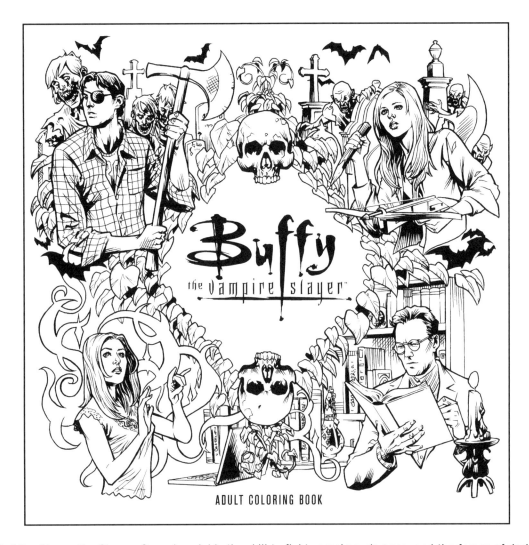

ADULT COLORING BOOK

Enter the world of the Slayer, the Chosen One who wields the skill to fight vampires, demons, and the forces of darkness . . . Favorite characters and moments from the beloved television series are represented in this delightful adult coloring book. In forty-five black-and-white, detailed, and original illustrations, you can add color to Buffy and Co.—and, of course, all the Big Bads!

Buffy the Vampire Slayer Adult Coloring Book

$14.99

ISBN 978-1-50670-253-7

Available at your local comics shop or bookstore!
To find a comics shop in your area, call 1-888-266-4266.

LOOKING FOR MORE TO COLOR IN THE WHEDONVERSE?

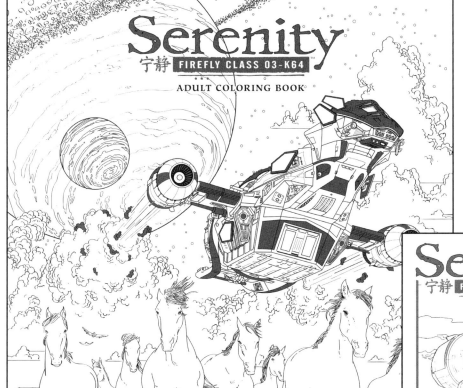

Serenity
Adult Coloring Book
ISBN 978-1-50670-253-7
$14.99

Serenity: Everything's Shiny
Adult Coloring Book
ISBN 978-1-50670-459-3
$14.99

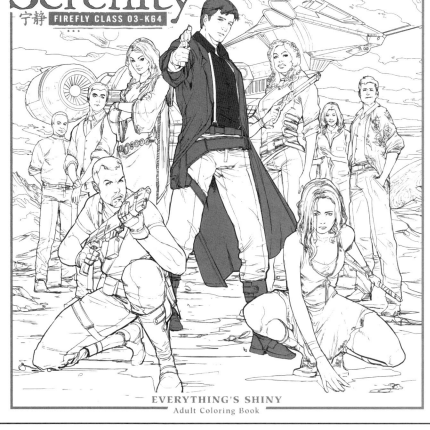

MORE FROM JOSS WHEDON AND DARK HORSE BOOKS!

SERENITY VOLUME 1: THOSE LEFT BEHIND
Joss Whedon, Brett Matthews, and Will Conrad
ISBN 978-1-59307-449-4 | $9.99

SERENITY VOLUME 2: BETTER DAYS
Joss Whedon, Brett Matthews, and Will Conrad
ISBN 978-1-59582-162-1 | $9.99

SERENITY VOLUME 3: THE SHEPHERD'S TALE
Joss Whedon, Zack Whedon, and Chris Samnee
ISBN 978-1-59582-561-2 | $14.99

SERENITY VOLUME 4: LEAVES ON THE WIND
Zack Whedon, Georges Jeanty, and Karl Story
978-1-61655-489-7 | $19.99

DR. HORRIBLE AND OTHER HORRIBLE STORIES
Joss Whedon, Zack Whedon, and Joëlle Jones
ISBN 978-1-59582-577-3 | $9.99

DOLLHOUSE: EPITAPHS
Andrew Chambliss, Jed Whedon, Maurissa Tancharoen, and Cliff Richards
ISBN 978-1-59582-863-7 | $18.99

BUFFY THE VAMPIRE SLAYER: THE HIGH SCHOOL YEARS—FREAKS & GEEKS
Faith Erin Hicks and Yishan Li
ISBN 978-1-61655-667-9 | $10.99

BUFFY THE VAMPIRE SLAYER SEASON 8 LIBRARY EDITION
VOLUME 1
ISBN 978-1-59582-888-0 | $29.99

VOLUME 2
ISBN 978-1-59582-935-1 | $29.99

VOLUME 3
ISBN 978-1-59582-978-8 | $29.99

VOLUME 4
ISBN 978-1-61655-127-8 | $29.99

BUFFY THE VAMPIRE SLAYER SEASON 9 LIBRARY EDITION
VOLUME 1
ISBN 978-1-61655-715-7 | $29.99

VOLUME 2
ISBN 978-1-61655-716-4 | $29.99

VOLUME 3
ISBN 978-1-61655-717-1 | $29.99

BUFFY THE VAMPIRE SLAYER SEASON 10
VOLUME 1: NEW RULES
Christos Gage, Rebekah Isaacs, Nicholas Brendon, and others
ISBN 978-1-61655-490-3 | $18.99

VOLUME 2: I WISH
Christos Gage, Karl Moline, Nicholas Brendon, and others
ISBN 978-1-61655-600-6 | $18.99

VOLUME 3: LOVE DARES YOU
Christos Gage, Rebekah Isaacs, Nicholas Brendon, and Megan Levens
ISBN 978-1-61655-758-4 | $18.99

VOLUME 4: OLD DEMONS
Christos Gage and Rebekah Isaacs
ISBN 978-1-61655-802-4 | $18.99

VOLUME 5: PIECES ON THE GROUND
Christos Gage, Megan Levens, and Rebekah Isaacs
ISBN 978-1-61655-944-1 | $18.99

BUFFY THE VAMPIRE SLAYER: TALES
Joss Whedon, Amber Benson, Cameron Stewart, and others
ISBN 978-1-59582-644-2 | $29.99

BUFFY THE VAMPIRE SLAYER: PANEL TO PANEL—SEASONS 8 & 9
978-1-61655-743-0 | $24.99

ANGEL & FAITH SEASON 9 LIBRARY EDITION
VOLUME 1
ISBN 978-1-61655-712-6 | $29.99

VOLUME 2
ISBN 978-1-61655-713-3 | $29.99

VOLUME 3
ISBN 978-1-61655-714-0 | $29.99

ANGEL & FAITH SEASON 10
VOLUME 1: WHERE THE RIVER MEETS THE SEA
Victor Gischler, Will Conrad, Derlis Santacruz, and others
ISBN 978-1-61655-503-0 | $18.99

VOLUME 2: LOST AND FOUND
Victor Gischler and Will Conrad
ISBN 978-1-61655-601-3 | $18.99

VOLUME 3: UNITED
Victor Gischler and Will Conrad
ISBN 978-1-61655-766-9 | $18.99

VOLUME 4: A LITTLE MORE THAN KIN
Victor Gischler, Cliff Richards, and Will Conrad
ISBN 978-1-61655-890-1 | $18.99

VOLUME 5: A TALE OF TWO FAMILIES
Victor Gischler and Will Conrad
ISBN 978-1-61655-965-6 | $18.99